A TIME TO FIGHT

A TIME TO FIGHT
LIVING AND REMEMBERING WWII

ROBERT D. ANDERSON

UNIFORM

Published by Uniform
An imprint of Unicorn Publishing Group
5 Newburgh Street
London W1F 7RG

www.unicornpublishing.org

A catalogue record for this book is available from
the British Library

5 4 3 2 1

ISBN 978-1-911604-93-8

Cover and book design Vivian@Bookscribe

Printed and bound by Fine Tone LTD

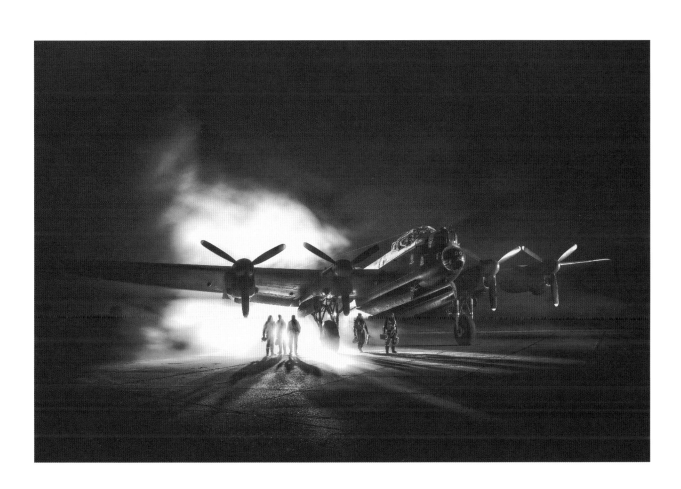

CONTENTS

AIR

SEA

WRENS/WAAF/NURSE

WAR-TIME CHILDREN

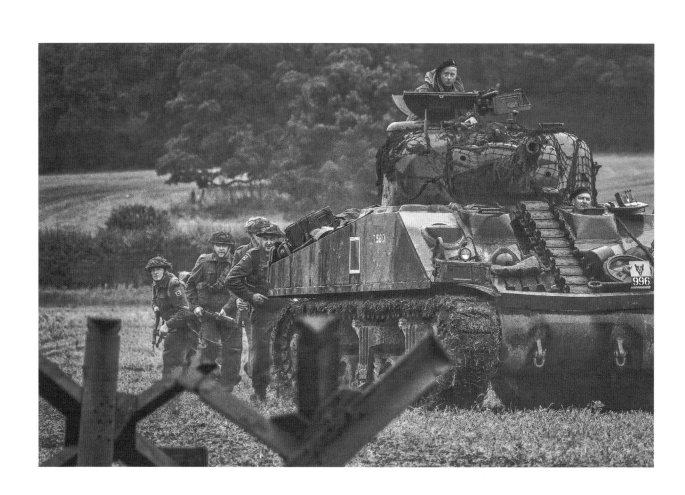

PRAISE FOR A TIME TO FIGHT

The young and old face each other, battling over the past.
Rick Warden – Band of Brothers

'A Time To Fight' captures beautifully a snapshot of memories.
James Deegan MC – Former SAS and Author

The excellent individual photographs, accompanied by their personal stories,
provide a fascinating record.
Neil Barber – Author

INTRODUCTION

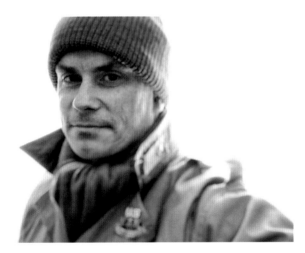

I took my first photograph when I was seven years old and that was all I wanted to do. Sure, I have had many detours on the way, but I got there in the end.

My name is Robert D. Anderson but you can call me Bobby, and I am a professional portrait photographer from London. Welcome, and thank you for taking an interest in my book.

My passion is photography and anything World War II-related, so how could I create a project that reflected both? Where would I start? My first plan of attack was to attend World War II re-enactment events. I had no idea it is such a big thing. The models even came with all their own props, with some actually used or worn in the war! I then started to think how could I make the images more real and less pretend – then came along Arthur Bailey, a Para veteran who I met, then photographed on a railway platform! As I drove home I thought of a way to incorporate the two in one image, living history actors looking seventy-five years into the future and today's veterans looking seventy-five years into the past. Of course war involves men, women and children, so I have also photographed women who served and children who loved the adventures of war. The finished image is therefore of two models who were photographed separately in very different environments, from churches, open fields, car parks, back gardens and tents to pubs, aircraft hangars, castles and veterans' homes, but using the same 'barn door' background.

Of course the golden nugget for me was meeting and hearing every veteran's personal recollection of their time spent in the war. It was an emotional time for them and for me. I felt humbled and somewhat guilty being in their presence, and seeing the tears in their eyes and hearing the quiver in their voice, but they felt it was their duty to get their personal story out to us all and for us to learn from their past.

I have made many good friends and unfortunately attended a few funerals whilst constructing this book. On my second meeting with Charlie Jeffries – a very proud veteran of the Highland Light Infantry – in an aircraft hangar, he beckoned me over to sit with him. He said, 'Bobby, I really do love the photograph you took of me, could you please send me a copy as I would like it placed on my coffin during my funeral.' I felt proud that he loved the photograph but obviously sad too. I sent Charlie his photograph. He died a few weeks later.

This project has been a labour of love and three years in the making, however I really do feel I have been working on this since I was seven.

To the few.

Robert D. Anderson

PETER DAVIES

My name is Peter Alfred Davies and I was born in 1923. I served in the RAF for two years and trained as a wireless operator and air gunner. In 1942 Monty was short of wireless operators in the desert, so I transferred from the Royal Air Force into to the British Army as a wireless operator in a tank regiment.

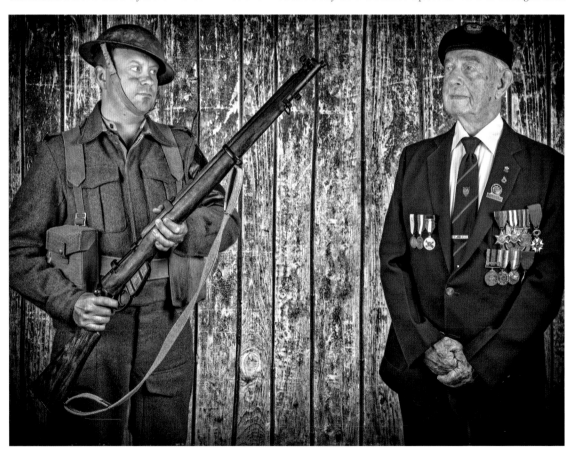

I served in the East Riding Yeomanry, Yorkshire Regiment that was equipped with Crusader tanks and ultimately swopped over to the American Sherman tanks which were in general use.

We trained in East Anglia and then suddenly moved to north Scotland by train with the tanks. We trained near Tain and Forres on the Moray Firth for three months, landing on the beaches on flat-bottom craft. We found out afterwards that the reason was the coast faced north and the tides were identical to the tides of Normandy, which also faced north.

We then moved down to the south coast for the eventual D-Day landings in Normandy. We were enclosed in a sealed camp for six weeks, no one was allowed out, we could not even write home. One man broke out and went to his home, but by the time he got there, the Military Police was there waiting for him, arrested him and he was imprisoned for six months.

On 4 June we boarded the landing craft. The weather turned bad during the night of the 4th and 5th, and the landing was postponed for twenty-four hours. The storm was tremendous and the barrage balloons broke off and everybody was getting seasick. I remember on the evening of the 5th, I went up to the top of this boat and had a look around, and all I could see for miles in either direction were landing craft; it was fantastic. Eventually, on the night of the 5th we moved out into the Channel. I looked round and had never seen so many ships in my life, I did not know we had so many ships. Apparently there were 4,000 ships. I saw one lone enemy aircraft come over in the middle of the Channel and that was immediately shot down, so he could not radio back – at least we assume that he did not. Having the landing delayed for twenty-four hours meant we were all getting fed-up and many of the lads were seasick. A friend of mine was lying on the duckboards moaning and groaning, saying that he was going to surrender to the first German he met because he was fed-up to the back teeth of being sick. So I kicked him with my boot to liven him up a bit and said, 'Get up, you'll feel a lot better not lying down there.'

As we moved in towards the beach, huge columns of water shot up in the air all around us – we were being shelled. We were all ordered to stop and hold our position. The RAF had bombed Le Havre the night before but apparently they missed one gun emplacement and this gun was firing at us. HMS *Warspite* was behind us, she suddenly turned and opened up and fired a salvo, which silenced the guns at Le Havre. When the battleship fired its four guns, it rocked the whole boat backwards and sideways in the water and then rocked back to its original position. We heard afterwards that the ship's Commander ordered only four guns to be fired and not the full eight because they would have smashed the crockery in the War Room, and to him that was more important.

We landed safely on Sword Beach not far from Ouistreham. It seemed so quiet that I decided instead of firing the main tank gun to blow off the main canvas sealing that stopped water getting in the barrel, I would jump out and cut it off with my jackknife. I put one hand on the barrel and with the other I started to cut the seal. I heard a ping and a piece of paint disappeared off the barrel. Suddenly it happened again, so I decided to give up taking off the seal and jumped nine feet up into the tank turret. I was welcomed back with huge laughter from the crew inside as I told them that a German had taken a pot shot and used me as target practice. My driver said, 'That's the fastest you've moved in years!'

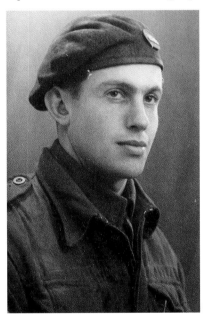

The Free French were not permitted to be in the first wave but somehow one chap did make it into our group. I found out later that he recognised his mother's house on the beach and asked his Commander for twenty minutes' leave and made his way to the front door. The door to the house opened and his mother stood there and he told her 'Mama, I'm home, and you're free!'

We moved inland and then held camp in a small French village near Caen. We bought a pig from the farmer. One of our lads was a butcher in civilian life so he dealt with it. The pig was lying in the yard in the chateau where we were. The Germans were shelling us heavily and our medical officer, who was driving an American half-track, was hit and the petrol ran all over the floor and exploded. Once the shelling had finished we got the pig sorted out; each tank crew got a chunk. We had a biscuit tin, so we decided to boil it over our little camp stove and shared it amongst our five-man tank crew. It had a funny taste; some of the petrol in the yard had spilt on to the pig while it was lying there. I was belching petrol fumes and gave up smoking for four days because I thought I might blow myself up if I lit a cigarette!

We were heavily shelled that morning. One of the lads took cover in a ditch and was yelling and shouting, and a couple of the lads shouted, 'belt up and stop bellyaching'. He quickly replied, 'It's all right for you, you haven't got your face in the entrails of that damn pig!'

It is comical, it is the humour, it is always there in the background. However serious your position

is and your life in danger, you will always get some clown come up with some comment about something which is hilarious. It breaks the tension.

At Christmas 1944 General Montgomery announced that those who had taken part in the D-Day landings were to be granted seven days' leave in January. To come home and see your family for six days was unbelievable.

My mother always kept the back door unlocked in wartime because three of her sons were in the forces – one had been killed, so she never locked the back door at night. I got off the train at Hereford station and knew when I got home the back door would be unlocked. I crept in, took off my kit, lay on the floor and went to sleep. I heard a slight noise about 7.00 am and my mother opened the door

Allied Military currency used to purchase the pig – legal tender issued to all Allied Invasion forces

in her nightdress and said, 'I heard a noise in the night and I knew one of you had come home and I prayed that it was you.' To her, having lost one son-in-law and one son in this war, and having lost her two brothers in World War I, the very fact I, as the baby of the family came home – it was a nice feeling.

We fought from D-Day to VE Day. Eleven months in battle, including the Ardennes supporting the Americans in the breakout there. A long time ago now, memories still there, some as fresh as ever, others fading…. I am a lucky man that I have lived this long.

It is part of life I suppose, I have seen so much in my long years now. I would never have dreamt I would be in my middle nineties, still running around – but there you are, I am a lucky man in so many ways in life. Just to be here now is great.

JACK WOODS

This is 7955816 Corporal Jack Woods, 9th Battalion, The Royal Tank Regiment. I had service from May 1942 to May 1947. I was an idiot; on my eighteenth birthday I walked into the recruitment centre and volunteered. I asked if I could join The Royal Army Service Corps but the recruitment officer told

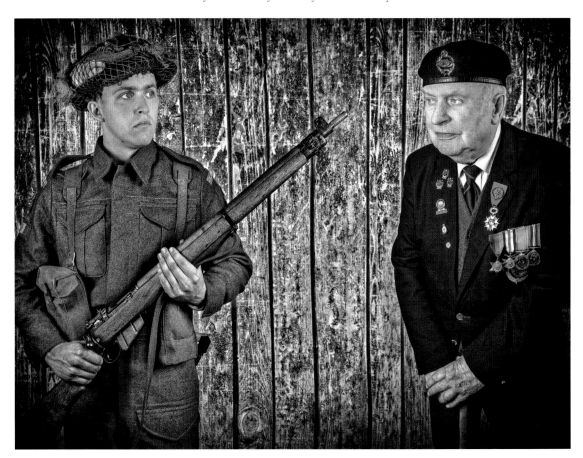

me they were full up, however they had room in the RAC. I signed up to the Royal Armoured Corps. I trained in Bovington, Dorset for six months before being posted to a Churchill Tank battalion.

I arrived in-between Juno and Gold Beaches with a column of tanks on each beach on 19 June. It was a horrendous journey, an American ship with food to die for … wish I had. We advanced towards Caen. The Humber Scout car driver had unfortunately trapped his finger in the hatch so he could not drive. I was the spare crew, playing cards in a big hole in the ground until Captain Ken Kidd gave me the order to drive. There I was with a Humber Scout car, which I had never ever been inside, let alone driven. I was told to run it around the field a few times and get used to it. The next day I went into battle; it was raining heavily – it was 26 June, Operation Epsom. After being hit, we had to bail out as we could see the counter attack coming towards us. I was lying on the ground and next to me was a Scottish Infantry Bren machine-gunner who said, 'Och go away, bugger off, this is my hole, dig your own.' It was every man for himself!

By now I was transferred to B Squadron, where I joined the crew of 9 Troop Leader's Churchill tank called 'Inspire IV', to help close the Falaise Gap with the 49th and the Canadians. We then crossed five rivers while fighting five battles to reach the river Seine, turned left and sat outside Le Havre for a few days before advancing into battle to support the 49th Division and take the town. Our next target was up into Eindhoven, Holland. We reached the famous corridor of death where the Germans were constantly breaking us; our job was to defeat them, and we did, and stayed in the city for ten days before moving on. Into Belgium for the Ardennes Offensive in December 1944 to support the 51st Highland Division and then on to help the Canadians liberate the towns and make a stand at the Maastricht Bridge. On 8 February we attacked the Germans up in the Reichswald Forest and swept up to the river Rhine. We crossed the Rhine in early April; we had heavy Churchill tanks so we had to wait for the pontoon bridges to be built. We advanced over the Rhine with a thousand guns with help from the 6th Airborne on my 21st birthday! I had no presents from home, but I had that! We continued into Germany until the war had ended in Europe.

VE Day had come, but there was still Japan. They decided to gather all the young soldiers to be part of the force to land on the second largest island of Japan. And then they dropped the atomic bomb. We were instead shipped off to Italy and on 3 March 1947 I was out. The 9th was a wartime unit and was to be disbanded before the end of 1945.

After the war I married, had one son and worked in fruit & veg. I have been the Secretary for The Normandy Veterans Association Norwich branch for the past thirty years.

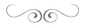

ALAN KING

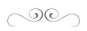

I am Alan King and I was born on 19 May 1924. When the war clouds were forming in 1939, I was too young to join the regular army, so I joined the Home Guard. The Home Guard needed a means of internal communication, so that was me, the emergency messenger unit; boys on bicycles!

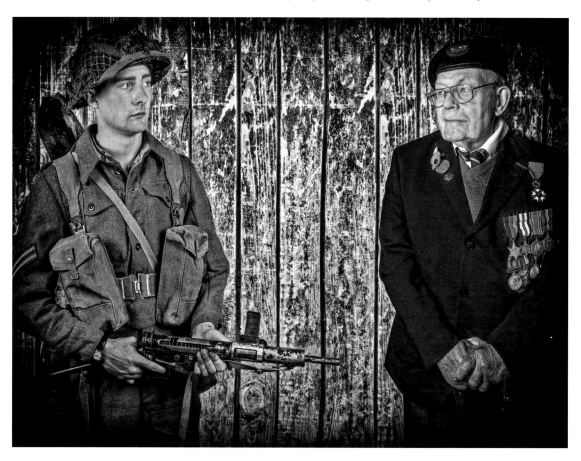

After the Battle of Britain we all thought the Germans would invade, so it was important to defend the river crossings. We lined up with five rounds of ammunition each to defend the bridges; five rounds to stop the German army!

I was called up in December 1942. I was eighteen-and-a-half by then, so I was expecting it. My father fought at Gallipoli in World War I; he had seen terrible suffering, so he did not want me to volunteer. I wanted to join the Royal Engineers but I was sent to the Tank Corps instead. I trained in Yorkshire, was then assigned to a tank crew with the East Yeomanry, 27th Armoured Division, then sent on to Suffolk, and then on to St Albans to pick up a Sherman tank and drive it back to Suffolk. It took two days!

In early 1944 we went up to Scotland for further training. We were sent there to practise beach landings but it was stormy on the Moray Firth and it was too risky to put the tanks out to sea, so we practised with lorries instead.

It was about 1.00 am on 6 June 1944 when we set off for the invasion of France. As we got closer to the Normandy coast, it looked as if the beach was on fire!

We arrived on Juno Beach on LST (Landing Ship, Tank) 3204 just after 7.00 am as part of the initial assault in a Sherman tank. On our landing ship we had one lorry and two tanks on either side. The sea was wild, we were all seasick and were glad to get off the ship. The lorry was hit and bullets were bouncing off the tanks. The lorry, full of tools and equipment to repair the tanks, was in flames. HMS *Warspite* opened fire. That was our signal to start the assault. A boat full of infantrymen alongside was hit by German shellfire; it sank and the soldiers were thrown into the sea. Some were dead and the injured were trying to save themselves but the ship behind went right over them. The propellers cut them to pieces. There were heads, bodies and legs in the sea. It was a terrible sight. I have never been in the sea since.

Four tanks managed to get on the beach. We started to move towards the beach and the German guns opened fire on us. Our tank was heavily waterproofed, so we could not turn the turret or fire the gun. The proofing was meant to blow off with a small explosion but that did not work! We managed to find a depression in the ground behind a hotel and took the covers off manually. I was the radio operator and could not get through to anybody. Everybody was swearing and cursing at everyone else; it was chaos.

On D-Day+3 we were ordered to go to Pegasus Bridge to take out the Panzer tanks on the other side of the bridge. On the way down we saw many gliders smashed up on Rommel's Asparagus. The cargo seemed to have shattered out through the front of the glider as they crashed; they were very flimsy craft built of plywood.

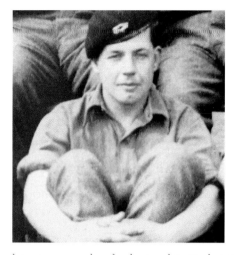

On 9 July, during Operation Charnwood, my regiment was ordered to attack German positions in order to secure land north of Caen. Our tank moved into a farmyard to attack a German gun emplacement. Corporal Louis Wilkes, our Tank Commander and, by this time, a close friend of mine, was firing a turret-mounted machine gun; his head and shoulders were out of the top of the turret, he was shot in the head, collapsed back into the tank and fell in my arms. The gunner held field bandages on his head; we backed out of the farmyard and returned to the first aid point. We all hoped he was only badly injured but he was pronounced dead by the medic. Three other crew and I dug a trench, rolled Louis in blankets and buried him in an orchard, placing his tin hat to mark where we had laid him. I found Louis' grave in the Commonwealth War Grave cemetery in Cambes-en-Plein forty years later, and I try to visit every year to leave a poppy cross on his grave.

To the west of Caen was a big battle for Hill 112, which went on for a long time. General Montgomery amassed three armoured brigades and other armed units, and altogether there were about 600 tanks to fight what would become known as Operation Goodwood, to the east of Caen. The Germans had 88 mm anti-aircraft guns, Tigers, Panthers and self-propelled high velocity 76 mm guns. We drove along the road toward a chateau and a German stood up and fired a bazooka that blew the tracks off our tank. We had to climb out and run for cover. I spent most of the rest of that day sheltering in a small stream while the battle raged around us. The chateau was blown to bits by our artillery, but we lost nearly 500 tanks in that battle. That is where we really understood the German nickname for our Sherman tanks; they called them 'Tommy Cookers'. In that battle so many men were burned alive in their tanks, afterwards it was sometimes not possible to tell how many bodies were inside.

After battling our way up to Le Havre, I was taken ill and sent to a hospital in Rouen. I was there for just over a week when an officer from the Coldstream Guards took every tank crew that could walk. I was destined for Operation Market Garden. We stopped short of Nijmegen and when the attack began and

the gliders came in, we could not get over Nijmegen Bridge. The Germans had flooded the land, so if the tanks left the road they sank. There were forty German Panzers which destroyed most of the tanks that got over the bridge.

After battling through the Ardennes, we finally made it to the river Rhine. By the time we crossed the Rhine only about half of the 600 men with whom I had had trained remained. My friend Corporal North picked up a party which was led by Churchill. He went across at dawn before Montgomery and Eisenhower! He was striding around; the other members of his party were ducking and weaving as there were still bullets flying but Churchill stood tall!

I finished the war up in Laboe, on the Baltic, in the sunshine. I was twenty-three years old when I came home in 1947. I had lost my best friend and many comrades in France. I had been more frightened, cold, tired and hungry than ever before or since. I witnessed horrors that I shall never forget, but I survived and have lived my life in a free country, and I still remember those who did not.

After the war I worked as an engineer in Suffolk until I retired. I married Nora and have three children. I was actually in the same tank group as another veteran in this book, Peter Davis. We still bump into each other at veteran events and talk about the good and the bad times we had back then. I am the President of the Stradbroke and District Royal British Legion, and I regularly travel to France and Holland to pay my respects to all my dear friends who did not come home.

WILLIAM MINTRAM

My name is William Mintram, I was born on 10 July 1918 and I was a Staff Sergeant in the Royal Tank Regiment. I first joined the Territorial Army before the war and moved into the regular army once war with Germany was declared.

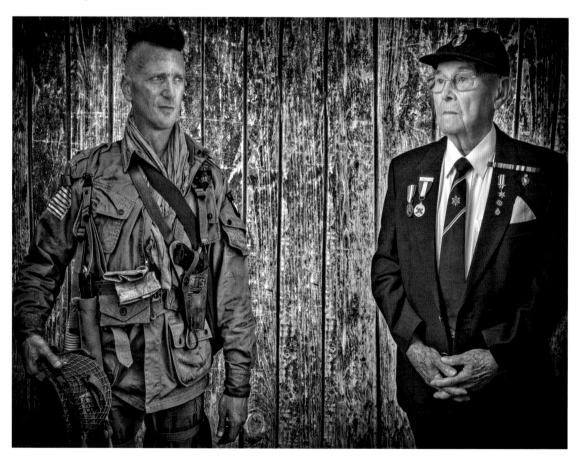

We were based in Folkestone, ready for D-Day. I had to wait for an American transporter because my tank was 50 tons, a Churchill crocodile with a flamethrower and we towed the fuel behind us. In the late afternoon on D-Day I arrived on Gold Beach, Arromanches. I said to the lads, 'I'm going to nip up to the farmhouse and get some hot water in this bucket for a shave.' I went up to the farm and knocked on the door and there was my brother with a towel round his neck – he had already had a shower and everything! He had been on a vessel earlier that day and had beaten me to it! Throughout the war I bumped into my brother five more times. We were all too busy doing our jobs, there was far too much action to worry about each other – the only time you would think about it was just before you went to sleep.

While in France, my Colonel came up to me and said, 'We've got a do on at the church, would you like to come?' I replied, 'Oh yes, of course, sir.' To my amazement there was a woman tied to a cross. All of a sudden fourteen blokes came marching round with rifles and lined up in front of her. I said, 'Oh no, I'm sorry, I'm not watching this.' My Corporal came up to me and said, 'Oh no, it's not what you think, c'mon.' So I stayed and saw two women come along and shave her hair, and from then on she was an unwanted woman in France. She now had a bald head and was known to be friendly to the Nazis.

William with his brothers – Roy left and Dennis right

We moved up to the Belsen Concentration Camp, and once completely emptied, we used our Churchill Crocodile tank to burn all the huts to the ground. We did this to stop any disease spreading.

I remember being in a square wireless vehicle in a German town and this German lady approached us and asked, 'Would you and your staff like to have lunch with us?' I replied, 'Oh, that's very kind of you.' We got to the house and one of the family was playing the piano and another was playing the violin, and they sat the three of us down. We had a cup of tea and a piece of cake. They were an ordinary German family. Not all Germans were bad Germans; not all Germans were Nazis.

RON COX

This is 14324222 Cox RCW Lance Corporal. I was born in 1924 and I was called up on Guy Fawkes Day 1942 and did my six-week training in Catterick, and was then posted to the Royal Armoured Corps, 11th Armoured Division as a Wireless Operator and Gunner.

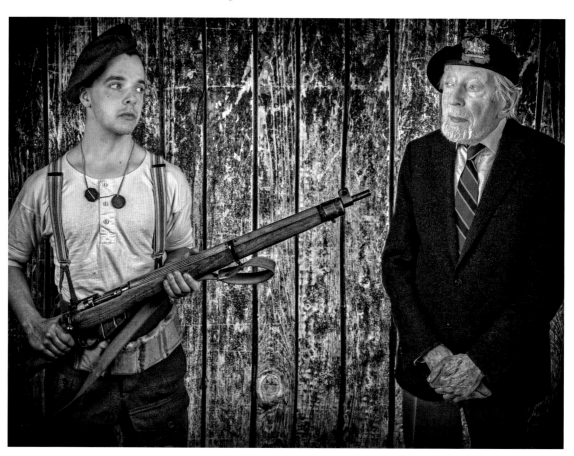

The training was fairly poor, as many of the instructors were not terribly good at their job, although we did have one chap who was a QC (Queen's Counsel) and who was absolutely brilliant. There was one snag: whenever an ATS (Auxiliary Territorial Army) girl passed he made a whistle to her and then we realised when he encouraged us to whistle, it was because it was his wife.

In May 1943 I was posted to the 2nd Fife and Forfar Yeomanry. Although we were English, we were accepted by the Scots. We were stationed for training in Bridlington, Yorkshire and parked our tanks in the streets outside the boarding houses. The people of Bridlington were absolutely marvellous – if one was on guard they would come out with cups of coffee. We spent the winter of 1943–44 in Bridlington. Most of the training was indoors. We did Morse code; however once we got to Normandy we never once used it as the tanks were so close together you could pretty well shout at each other.

In May 1944 we moved down to Aldershot, Surrey. We knew we were destined for the second front but we did not know more than that. My regiment went over on D-Day+9 when I was twenty years and thirteen days old. We landed on a beautiful summer's evening, came into about one foot of water and hastily rushed inland to get us off the beaches – then did nothing much until 26 June because of the big storm. On the 26th we took part in Operation Epsom. My leading troop of the 11th Armoured Division took the village of Cheux. As we left Cheux, two of our four tanks were shot up so we were then stuck in the village, not knowing what was happening for the rest of the afternoon and evening until we were able to reverse out after dark.

Two nights before Operation Goodwood we moved round the north of Caen. We had to be camouflaged and lay quiet on the second day because the theory was that the Germans did not know we were there but of course they did. I went to a farmer's gate and he sold me some warm milk and I drank it and for the next forty-eight hours I was more concerned about getting tuberculosis than I was about death on the battlefield!

On the morning of 18 July we moved forward and we believed we would be in Paris by that evening. Our attack was preceded by an enormous bombing expedition carried out by the British and the Americans; it was inconceivable that anything under those bombs would survive. That was true but the troops that were not under those

bombs were there, waiting for us when the bombing stopped. We advanced at walking pace and at first it all went well. It was supposed to be good open-tank country. We crossed the first railway line and realised that the tanks in front of us had stopped and things began to happen in a really unpleasant way and fairly soon our squadron was ambushed. We had lost fifteen out of nineteen tanks in thirty minutes. I had an excellent Firefly tank crew, so when we realised we could not see or hit anything because of all the smoke, we thought it judicious to start reversing. Very calmly we started to reverse, zig-zagging a bit in the hope that we would not be noticed. Then suddenly there was a tremendous crash; the offside track had been taken away so therefore we were immobile. We had a choice of being a stationary gun platform and winning the Victoria Cross or bailing out, and rather sensibly I feel we quickly bailed out. We hid behind the tank. For a short while my driver disappeared then reappeared and we asked, 'Where have you been, Charlie?' He replied, 'Oh, I went in to get my small pack.' He had gone back inside the tank to rescue his shaving equipment and his love letters.

We moved back on foot across the battlefield, picking up people who had been burned and eventually picking up some German prisoners, and we went back to where the gliders had landed on D-Day. We foolishly were told to remain there whilst reinforcement tanks were brought up the next day because there were very few Luftwaffe attacks during Normandy, but this was one of them. After all, all the Germans had to say to the Luftwaffe pilots was, 'You know where those gliders are, so just drop some bombs and you're bound to hit something.' That evening we listened to the nine o'clock news on the radio from London and they announced that the air raids had started and the Luftwaffe had hit ammunition trucks and petrol trucks. We hid under a tank, which was a very safe place to be in an air raid, but it got so hot there that we had to get away and I ran across the field and saw a ditch in front of me. I dived into this trench and that is the last thing I remember for the next twelve hours. I bumped into some British infantrymen after coming to, who were fairly new and trigger happy, and they were puzzled, as I was a tank man wearing denim overalls and, being a Lance Corporal, I did not have a rifle, I had a pistol. They were highly suspicious, they stood round me in a circle, but I was still non-compos mentis after being knocked out in the trench so the more questions they asked, the more confused I got. I heard one of them say, 'Let's shoot the bugger, he's a spy' – fortunately somebody with a bit more sense said, 'Let's speak to the Lieutenant first before we do that!'

We were ambushed because we did not have any infantry support, as the infantry losses were so great. They felt tanks were expendable and there were plenty of tank men.

There is a fallacy that when a tank is hit everybody is killed but that is not so. On balance, I should think probably that in a five-man tank one would be killed, two would be wounded and the rest would get out – in my case we all got out.

I was taken back to the first-aid station, then back to a house that was being used as a hospital and I spent the night there – there was no room in the house so I slept on the grass outside.

The important principles as far as Normandy was concerned was to get the bridgehead cleared so anybody who was killed was very quickly removed, not back to the England but decently buried. Anybody who was not fit for any further action was immediately carted back to the England.

So on the morning of 19 July I was taken in a DUKW boat which was a wheeled vehicle that could go into water, put on board a tank-landing craft and was returned to England. After being transferred from various hospital and convalescent homes, I managed to get back into uniform at the end of December 1945.

Ron with Aunt Emily Baker and Uncle William Baker

I am very glad I did not miss this experience, although sadly I lost a lot of friends. It gave me a lot of confidence. After the war I became a teacher and, believe me, facing 4C on a wet Friday afternoon was nothing after facing Tiger tanks in Normandy!

I married Audrey and had one son and now have three grandchildren and seven great-grandchildren.

I had great pride in what I had done because I was absolutely sure we were right to be there and to be at war. However, I have a feeling since then there has not been a single war in which we have been involved that can be justified or worthwhile, and it is for that reason I do not wear my medals.

It is only until recently that I have talked about the war – except to my grandchildren who want to know, and now my great grandchildren are asking questions like 'What suit did you wear?'

RON PEARCE

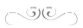

My name is Ron Pearce and I was born on 13 July 1918. I received my call-up papers four days before my twenty-first birthday – what a shock that was!

I was to report to the Royal Artillery training camp in Blandford, Dorset on 17 July 1939. What a

sight! Nothing but bell tents everywhere. It was ten to a tent, all playing soldiers, and we got seven shillings and six – we sent five home and it left us with half a crown for beer. They found out that I was a GPO engineer, so they sent me off to do a course on radio, which I liked.

In August 1940 I found myself on a troop ship to Egypt. While on the ship I was recruited as an electrician and classed as crew, as they were short of staff, which I did not mind at all, as I received better food and a nice cabin. We sailed through the Suez Canal, landed in Port Said and took the train to Alexandria. I set up No. 1 Base Workshop at Alexander Docks and we repaired everything from tanks to wristwatches – you name it, we done it. I then went on to maintaining radio equipment on tanks so that our troops could get out of Tobruk as the Germans advanced. We then made the big push on El Alamein. It was absolutely deafening, I lost part of my hearing there; you never heard such a roar. Luckily it was a good manoeuvre and we held out. We got the Germans on the run and once we got to Tunis the Germans had decided they had had enough and surrendered. We won the North African Campaign in May 1943.

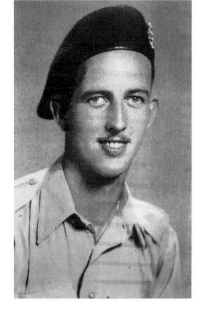

I went home to Portsmouth on a two-week leave. We thought we would never go home; we thought we were going to be in Africa until doomsday!

I arrived at Paddington Station, London where my father said he would meet me. I got off the train and saw my father in the distance with a Regimental Staff Sergeant; my father was the Commandant of an internment camp for the VIPs. So I saluted, nothing, I saluted again, still nothing. My mate said to me, 'Are you sure that's your old man?' I replied, 'Of course that's my old man.' He said, 'Well, he's not taking any notice of you.' The Regimental Staff Sergeant came over and asked me, 'What you doing? You've just come off the train and you keep on saluting!' I quickly replied, 'Well, you go back and tell the Colonel to put his bloody glasses on because his son is standing here!' The reason he did not recognise me was because I was absolutely burnt solid. I had spent two-and-a-half years in bright sunshine and I was tanned all over.

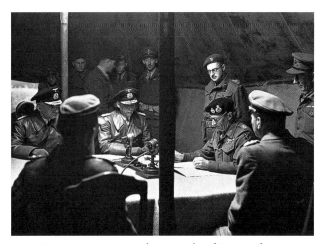
Montgomery receives the surrender of German forces

I then joined the 79th Armoured Division, which had amphibious tanks, flamethrowers and everything you could think of. We had this horrible black stuff to put on the tanks so the water would not get in; it used to take ages to get off our hands!

We assembled at the woods in Cosham to prepare for the D-Day crossing. We went over on D-Day+2 and pushed on to Caen, then on to Arras to set up a workshop in a former German HQ. You could see bullet holes all over the walls where the Germans took people in and just shot them. Before the Germans moved out of Arras, they damaged all the radio lines so we had to get the communications back up and running.

From Arras I went up to Belgium and through Holland. I then modified the nineteen wireless tank sets for direction finding to cross the Rhine. Into Belsen and then Lüneburg to set up another workshop. Little did we know then, but the Germans were about to give up. Monty saw these German officers walking up the pathway; they had come to surrender the German North Army but Monty sent them back with a flea in their ear as he told them he would only accept a complete unconditional surrender of all German forces. They came back the next day, and on Friday 4 May 1945 I witnessed the signing of the terms for surrender. On 7 May the unconditional surrender to Allied armies of Britain, America and the Soviet Russia was signed. I stayed in Germany until April 1946.

I came home and got my old job back again as an engineer with the Post Office.

These days I still keep busy in my office at home as the Royal British Legion Surrey County Treasurer.

JEFF HAWARD

My name is Jeffrey Haward and I was born in July 1919. In November 1937 I joined the Territorial Army Battalion of the 1/7th Middlesex for three reasons: I knew quite a few of the people in it because they had been recruited from the same area as me, because it was a recognised battalion and because

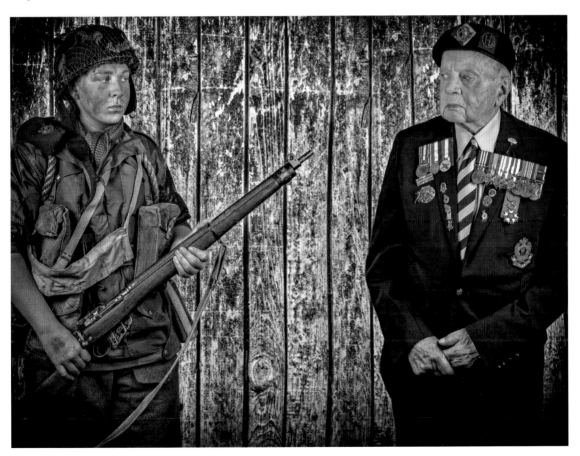

I could walk there as it was close by.

We were mobilised on 1 September 1939, when Germany invaded Poland. In January 1940 we crossed over to France near the town of Lille. When the Germans invaded the Low Countries in May, we were moved up to Belgium to help out and we got as far as Louvain on the 11th. We were not involved in any really serious fighting because every time we took up positions, the Belgium Army kept falling back. Later, we ended up by the river Lys, which is on the border between France and Belgium at a town called Wervik. Our Colonel wanted to know what was happening on the Belgium side, so he sent a patrol of eight men under a Sergeant across the river in two dinghies while we covered them from our side with machine guns. They had been there a short while when a German came cycling along the road, so they shot him and pulled his body and his bike into the ditch. Shortly after, a blue car drove up. They shot the driver and officer inside, and another officer in the back jumped out and ran away, leaving behind his cap, belt, Luger and briefcase. So they grabbed it all, brought it back and it was taken to the division headquarters. General Alan Brooke happened to be there and discovered the briefcase contained the German plans to attack and capture Dunkirk. Montgomery was our Divisional Commander at the time and was able to shift our division 25 miles sideways and put us in a position to stop the German Panzer tanks getting through. But we did not know if the plans were genuine because the briefcase also contained a shoehorn, implying the officer had tight boots – it was later discovered it was a German officer called Kinzel who did, indeed, have tight boots.

We then fell back and eventually arrived in Dunkirk. During a skirmish one night when the Germans were attacking us, it was chaos and I was shot by one of my own blokes by mistake! It was only a flesh wound in my right shoulder but eventually we all made it back to England. We arrived in Folkestone and waiting for us were all these ladies from the WVS [Women's Voluntary Service] with cups of tea and cake, and they saw me with a torn blood-stained battledress so they all grabbed me – their wounded hero. I was in more danger from those ladies than from any blinking German!

I was then moved to the 51st Highland Division as a machine-gunner and went out to the Middle East and our first battle was El Alamein. We marched into battle with a piper leading us and we ran into an unmarked minefield, so we stayed there for three days. We then saw our tanks from the Armoured Division and on the opposite ridge we saw tanks from the German 15th Panzer Division. They were shooting each other and we were stuck in the middle of it! Anti-tank shells do not have an

ark of fire, you fire them straight and direct, so the shells were flying just above our heads – not a very nice situation to be in!

In July 1943 we went on to the invasion of Sicily. One night we were attacking a German aerodrome, I jumped over a trench and a German was sitting in it and he fired his Luger up at me and hit me in-between my legs. It does not hurt at first, it stings but the real pain comes later. Our stretcher-bearer ran up, a little Jewish boy – one of the best – we called him Nobby. I asked him, 'Is it all there Nobby?' He said, 'I'll have a look', so he pulled my shorts down and he said, 'Yes, but I don't think you'll be using it for a while!'

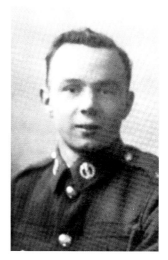

For the D-Day landings, the 51st Highland Division was called a follow-through division: they used new troops for the landings because they did not know what they were doing or what they were going into and we knew when to duck! So we went in the afternoon of D-Day, landing on Sword Beach and took any hot strong points that had been left behind by the assaulting troops, as they had to get as far inland as possible.

We ended up attacking this German radar station and we were told none of our troops were there. When we got there we saw soldiers in camouflage smocks and what we thought were German helmets – our Paras were similar from a distance. We started skirmishing with each other. I had a brand new officer and this was his first time in action. When we got close I said to the Officer, 'I know these Germans can speak English but they can't bloody well swear like that' – they were Canadian paratroopers who had been dropped in the wrong place and were trying to make their way back!

We then went on attack with the 5th Black Watch and were to capture a town called Breville, which was on the high ground overlooking the landing area. We thought we were the cat's whiskers; we had just beaten the Afrika Korps and we thought we knew everything but we were in for a terrible surprise. When we were just about to attack, a parachute officer said to the Black Watch officer in charge, 'I wouldn't go up there because all the Germans are in a ditch waiting for you.' I remember the Black Watch officer replying, 'Don't tell us, laddie, we've just beaten the Afrika Korps.' That afternoon the Black Watch lost 110 men and over 200 were injured, so were learnt a terrible lesson. We were not quite so clever as we thought we were.

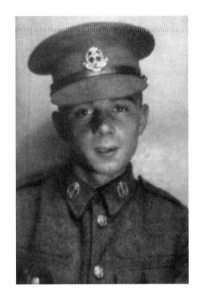

We fell back into a chateau; we had suffered many casualties and had only one machine gun. We were trapped; our guns were water-cooled but there was no water in the chateau. We got a big pot out of the kitchen and everyone had to pee in it. Our last gun had a fracture in it, so when it got hot all the steam came out but it was not water coming out, it was boiling pee, and the officer said, 'Nobody is to drink any more of that rot from the cellar, I don't know what's worse, this or the Germans.'

The Germans were ready for a full frontal attack. One of our men had a very powerful wireless and managed to contact the Destroyer HMS *Arethusa*, and they fired shells right on the German tanks – that is what saved us. We were relieved by the Ox and Bucks (Oxfordshire and Buckinghamshire), the Glider Regiment of the 6th Airborne.

Our next mission was to attack a steel works in a town called Colombelles that had big towers that were being used as an observation post by the Germans. We tried to knock them down with artillery but it did not work. The next day we were told to keep down, as a formation of Blenheim bombers were coming over to bomb the steel works. It disappeared in a cloud of dust and the first thing that appeared were the towers, still standing! Together with the Black Watch we decided to attack it long enough for the engineers to lay chargers to blow up the towers. We followed the Black Watch up to the towers and took another terrible beating. As a result, our Divisional Commander was sent back to England and replaced. Our original Commander from the desert, 'Wimberley', had been promoted so they fetched this fellow Major-General Bullen-Smith and he was a Lowlander, so of course the Highlanders did not like him. A smashing Highlander called Major-General Tom Rennie replaced him and he made all the difference. Unfortunately he was killed at the crossing of the river Rhine; he was right at the front.

Once we had crossed the river Rhine into Germany, we advanced rapidly. We did not think the Government would look after us after the war so we thought we would try and get a few bob. We found an intact bank with a big safe in it. So we thought about opening this safe with an anti-tank gun. We got the gun ready to fire and our Sergeant Major came along and asked us, 'What are you

going to do?' and we said, 'We're going to open the safe because there might be a few bob in it.' He replied, 'I'll have a go', and he took the anti-tank gun into the bank to fire it from there. I said to him, 'What are you doing? You'll kill yourself with the blast.' So he took it in the road and pointed it through the bank window towards the safe. He fired it and the next thing we knew he disappeared up the road in a cloud of smoke! When we went into the bank all that was left in the safe was a bit of charred paper and a few bits of melted goodness-knows-what because the shell had destroyed everything, so we got nothing out of the bank.

Near the end of the war we were in the Reichswald Forest with my machine guns ready to fire. To my surprise, walking up the firebreak was this German. We were all in our mid-twenties and I imagine he was in his forties, which to us was old. He wore steel-rimmed glasses, with his rifle on his shoulder, and he was plodding along with his head down. For some reason I had taken off my equipment. My weapon was a Webley 48 pistol so I was un-armed, and I thought, 'I cannot let this German wander about and kill one of my platoon.' So I waited until he got close, stepped out from behind a tree and shouted, 'Hey, comin zee here, hande hoche.' The German looked at me nice and slowly, then slowly took off his rifle, fired at me, missed, fired another shot, missed again. I realised he was shell-shocked and then he decided he had enough, put his rifle back on his shoulder and started to walk away. My platoon was now aware of the shots fired and the first one up to me was an Irish boy who stuttered when he got excited. I said to him, 'Paddy you will have to shoot him, we cannot let him wonder around.' Paddy would not shoot anyone in the back, so he was trying to tell him to halt but he was stuttering. I did not know what he was talking about, so I am sure the German did not know what this stuttering Irishmen was saying either! I did not want to kill the German, so I took a Sten gun and shot him in the top of his leg. He fell down and I went up to him and said, 'It was your own fault, you should have stopped.' He had two breast pockets and I went to get what I thought would have been his pay book and he said, 'Nein, Nein, Nein, Nein.' Paddy said, 'Oh he's got a few bob in there,' so I opened his pocket and in it was a picture of a woman and a child. I asked him in German, 'Your wife and child?' and he said 'ya, ya'. We all had a look and said 'very nice'. I put his picture back in his pocket for him and by then the stretcher-bearers had come up. I put a dress on his leg – it was only a flesh wound – and the four of us had to carry him a quarter of a mile back to the field dressing station. We all sat down together, including the German, and had a cup of tea and then we put him in an ambulance. I told him, 'You'll have a limp but at least you'll get home, more than some of us would.'

I was awarded the Military Medal for my actions in Reichswald and it was presented to me by General Montgomery. Unfortunately, when it was my turn for him to pin it on me, the official photographer was changing his film but someone in the back took a photo.

In my opinion General Montgomery was all right. He never did anything unless he had the tools to do the job. When we were in the Ardennes they put one of the American armies under his command and Patton kept running him down, but if he was that bad why did they put an American army under him? In my opinion he was all right. Patton running around with two pearl-handed pistols; I do not know if he ever shot anything with them. I doubt it very much.

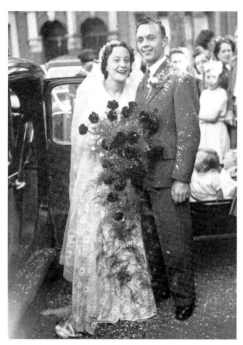

Our next objective was the German town of Bremerhaven. It was a lovely afternoon. The Black Watch was going to attack a village on the way and to the side was a forest. We knew the Germans were in there and they laid fire into the Black Watch as they advanced to the front, so we fired harassing fire into the woods to try to keep the Germans down. As we fired, a Black Watch officer came up to me and said 'Cease firing, Sergeant, the war is over.' And that was the end of the war for me.

For want of having anything stronger, I said to the cook, 'Make us all a cup of tea'.

After the war, I went to work on the buses, met my future wife Ivy in the canteen and had two sons. I made my first visit back to Normandy in 1994 and I go back every year to catch up with fellow veterans to pay my respects to those who never came back.

Jeff's wedding to Ivy on 25 Sept.ember 1948

CHARLES JEFFRIES

My name is Charles Jeffries, I was born in 1922 and I served in the Highland Light Infantry.

I was called up in 1942. Having done my training with the Rifle Brigade, for some unknown reason I was sent to the Highland Light Infantry. Some wondered why a Sassenach was coming along to a

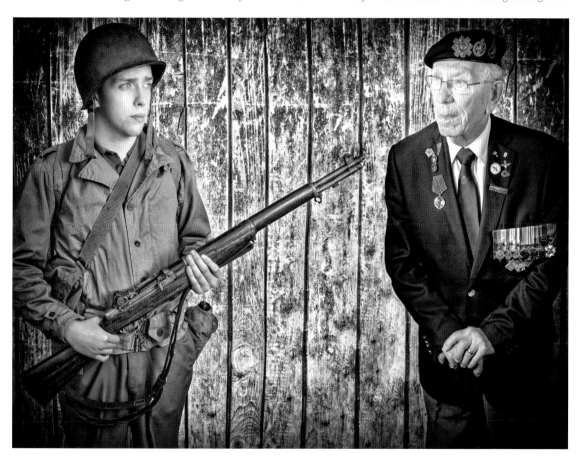

Scottish Regiment; I myself also wondered why, but then again there were quite a few London boys in the regiment. One in particular, I would love to find out if he is still alive – Jimmie Jones from Mile End, a great pal, wonderful. I have often thought of him but to no avail; I've never come across him.

I came back from fighting in North Africa to get ready for the invasion of France. It poured with rain the night before so the invasion was cancelled. We were all young boys – eighteen, nineteen – and war then was quite an aspiration for us. We thought, 'let's go to war, we can do it'. The next morning we landed on Sword Beach and my feelings changed! It was absolutely horrific. Seeing men float around in the water, limbs off, just absolutely horrendous.

We started to make our way through several villages. Our target was the town of Caen. We arrived at Hill 112; there was quite a battle going on when we arrived. There were German reinforcements and some of the best fighters of the German army on that hill. I was called out of a trench to get a cup of tea and a shell burst in front of me; I received a wound in my leg. I will say the evacuation of the wounded was absolutely fantastic. I was taken back to a field hospital and within a few hours I was put on a Dakota aircraft and taken back to England. We landed in Derby. We were treated very well and were given stationery to write home to relatives, a book of stamps, a bar of chocolate and half a crown

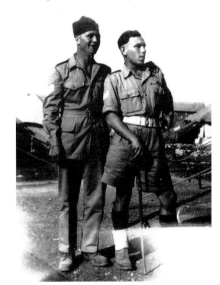

– which was a lot of money in those days – which we thought was absolutely wonderful.

The chappie who was in the bed next to me actually flew home from Normandy with me, and my family came up from Birmingham to visit often and we all got on well together – and to cut a long story short, he fell in love and married my wife's sister!

I eventually got back to my battalion who were by now in Belgium. We then moved up to Holland, then into the Reichswald Forest. We were actually in the forest for a month. It was the rainy season, men were bogged down and artillery could not get through. We were told to leave our knapsacks in the trench and to take our rifles, ammunition and any shovels, and we went down to Chewing Gum Alley to chop down trees for the vehicles to get through. Well, that took us all night.

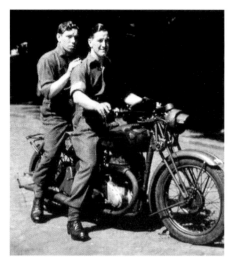

When we went back to our trenches, there was a shout, 'Someone's been at my chocolate and cigarettes!'. At the time I was a Sergeant and I said, 'Have a rest, later on we'll sort things out.' One of the sentries informed me that there was movement in the bush on the far side, so I went over to investigate, and there they were, two Germans sitting there smoking away, with a bar of chocolate beside them! I reported this to the Company Commander and asked, 'What shall we do with them?' I cannot repeat what we did to them.

We finished up in Hamburg for the end of the war. We were stationed near the canal where it was reputed that a barge was stuffed with whisky and gin. We noticed the next day that the barge had risen six inches out of the water overnight.

We were then flown back to Belgium and were informed we were going on to Canada or America for the invasion of Japan. But of course they dropped the Atomic bomb. I finished the war as a Brigade Sergeant Major with three regiments under my command.

I would have stayed on but my wife wanted me home. Otherwise I would have definitely stayed in because I enjoyed every moment. One remembers the good times – you think of the bad times but you remember the good times.

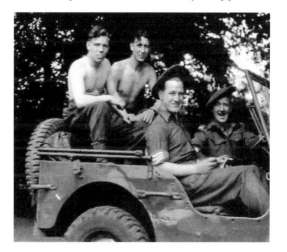

I went back home to my trade, which, being a man surprises some people, but I was a milliner making ladies' hats.

I was married for sixty-eight years and had two beautiful daughters. I lost my wife six years ago. That is the story of my life.

ERNEST CHAMBERS

My name is Ernest Chambers, I was born in 1925 and at the age of eighteen I volunteered for the Royal Electrical and Mechanical Engineers of the 51st Highland Division.

My brothers were in the Royal Navy and my mother would not sign my papers to get in, as I was

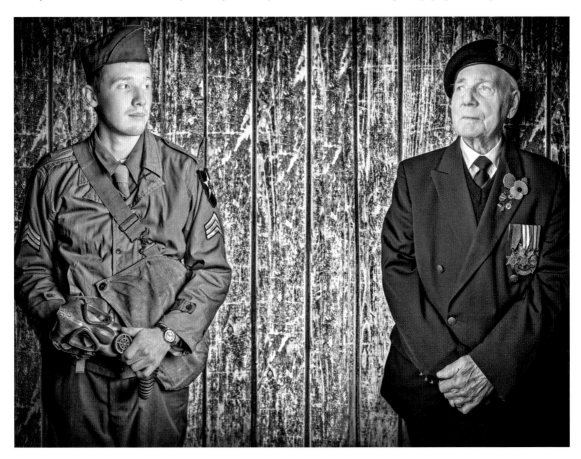

too young, so I joined the army instead.

I landed on Gold Beach, near Arromanches, on D-Day+19. We then marched to join up with the battle for Bayeux. We progressed into Belgium, Holland and then finally into Germany.

I was demobbed in 1947, and three months later I met my future wife, with whom I have three children. I started work as a painter and decorator and continued until I retired. I have made the trip back to France a few times to the towns and villages where I fought, to pay my respects for those who never came back.

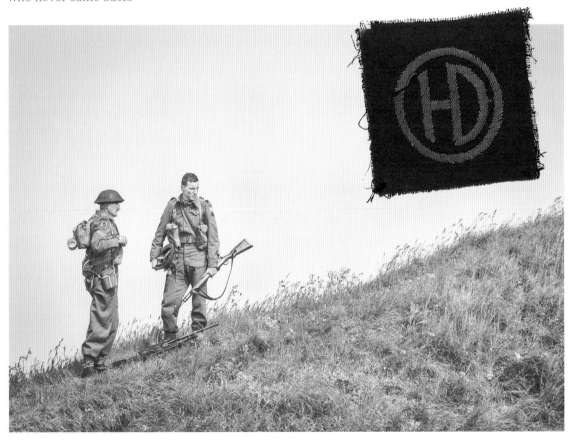

LEONARD BENNETT

My name is Leonard Bennett, I was born in 1925 and I joined the Royal Corps of Signals in 1942 at the age of seventeen.

I was in the Air Formation Signals and communicated with the RAF Second Tactical Air Force. I

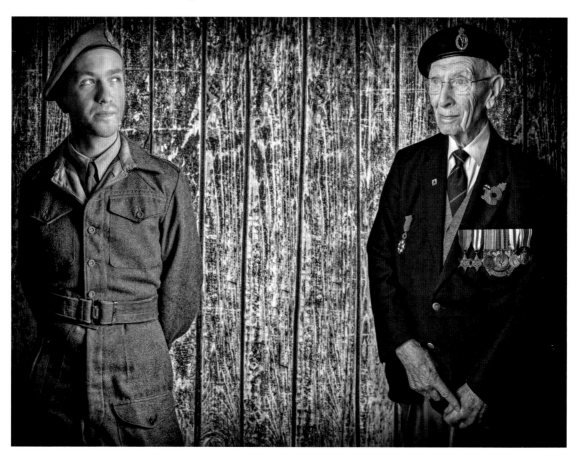

landed on Gold Beach on D-Day+20 and travelled through Normandy. I went home on leave and was then posted to Egypt for the big battle at El Alamein.

I landed on the beaches of Normandy and finished up on the beaches of the Baltic.

I was demobbed in 1946. I enjoyed my time in the army but was glad to leave as I had a good job waiting for me. I joined the police force, got married and had two children, a boy and a girl, and I retired as a Superintendent.

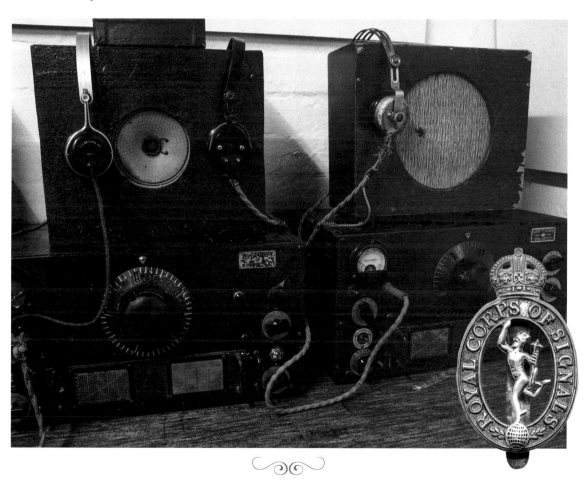

TED ADCOOK

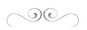

My name is Edward Andrew Adcook and I was born on 27 July 1918. When my call-up papers arrived, my father being a postman delivered them himself. Our house was on his route and at the time my mother was ill in bed. I went up to her room to say 'cheerio' to her before going to work and I found her

in a coma. She looked as if she had gone into shock; she died two days later. My father's voice carried up the stairs and I firmly believed that the news killed her.

From 1938 we knew that war was imminent but we had twelve months' grace. I shall have to be honest here: I was disappointed. I had been in a miserable job since I was sixteen, hard work, no prospects, so I looked forward to joining the army, I was looking for a bit of excitement. I joined the army on 15 July 1939. I was the first militia soldier in Hemel Hempstead. I was meant to go in for six months but it turned out to be six-and-a-half years.

I was sent to the barracks in Kempston, which was the headquarters for the Beds and Herts Regiment and was there until March 1940 when we were sent to France. We were a hundred men; seventy-five of us were transferred to the Queen's Royal Regiment. There was nearly a mutiny because we did not want to leave the local regiment to join what we called a foreign regiment. Anyway, we settled down in France in Rouen. All we did was paint Nissen huts in a very hot summer, I remember, in 1940. We got our orders to move south and we were on the march for several weeks, hardly any food, pouring with rain, we had to sleep under trees, we were in a right old mess. We were put into hedges and we were given strict orders not to move out of the hedges. After a few days in the hedges we then marched to Le Mans. We did not know what was happening and the next thing we were stuffed into railway wagons and off we went. We landed in Cherbourg and then put on a cross-Channel steamer and ended up in Southampton. It was only then we realised we were being shipped out of France because of Dunkirk.

We eventually moved to Dymchurch and had a grandstand view of the Battle of Britain. As the aircraft were shot down, it surprised us that all the aircraft we had to guard were British Spitfires and Hurricanes; we never did see a German bomber or German fighter being shot down.

We then made our way to Liverpool, then on to Scotland by ship, then on to Cape Town, and then on to Bombay. Eventually General Montgomery, who was our Commander in England, ordered us to go to the African Campaign. We had 3,300 miles to travel in the backs of lorries. We finally went into action in Tunisia. We lost one or two men, we were attacked all the time, bombarded by mortar fire, shell fire and machine-gun fire by the Germans who were at last on their 'B' men. They had nowhere to go so they threw everything at us: it was like coconuts at the fairground and they were throwing all their balls at us.

The next day the Italians attacked us. They fired their machine guns; we were in their sights as we

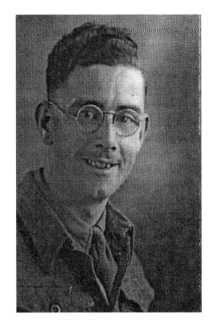

tried to get up the hill to them. As I stood up the bullets went right past in front of me and I went down pretty quickly I can tell you; that was the nearest thing in North Africa, I was nearly killed. They bombarded us all day and machine-gun fired us at night because they knew we moved forward at night. I tried to fire my gun but it was jammed with sand. One of my men said, 'Shall I fire this, Sergeant?' He had a grenade on his rifle and I shouted, 'You fire the bloody thing,' and we knocked the Italians off the mountain.

We sailed from Tripoli to Salerno in Italy. We were the first to land and the Germans started firing guns with shrapnel in them – anti-personnel shells. One or two of our blokes were knocked out I suppose but it was pitch black and we could not see. I landed all right but some had to climb over bodies. As a Sergeant I was in the rear of the landing boat. As we hit the shore, our chests hit the water and we were surrounded by barbed wire. Somebody managed to cut the wire and we got through but there was no machine-gun fire coming at us, only shell bursts. We were making for a tobacco factory but were held back for a day by snipers who were firing left, right and centre. We eventually managed to take care of them and made our way through the tobacco fields – what a hell of a job that was, with all these wires attached to all these plants. We got on to the road; pitch dark then fire opened up behind us and we knew we were on the wrong end of the airfield which was our next target. I dived into a deep ditch and ordered my men to do the same, as I could see up the road Tiger tanks were approaching. All of a sudden our Company Commander shouted, 'Get these men out of here Sergeant,' and that was the last words he uttered in his life.

We got out of the ditch, through a hedge, through the woods and into a field. I looked back and I could see a Tiger tank on the bridge firing at the rest of my platoon. I had only five men with me in the field and I shouted to them, 'Get down, get down!' but they did not hear me. The men went down like ninepins. My shouting alerted some Germans who were behind me because they started firing in the direction of my voice. Well, all hell broke loose and I did not know what to do. I thought if I

could get into the woods I would be safe, then all of a sudden the firing stopped and I realised what had happened. The stretcher-bearer was one of the men with me, he had a stick, and on it was a white handkerchief and he was waving it. I lost my temper; that was my duty, not his. I have thought about that moment every day since. We put up our hands and as we walked I could see a German half-track with a heavy-duty machine gun and about twenty or thirty German infantry around it. As we walked up the road there was a chap lying on the road wounded, it was a bloke I knew, Tom Gordon. I said, 'What the hell are you doing there Tom?' He pleaded, 'Don't leave me Serge, don't leave me.' I said, 'I won't leave you Tom.' Despite his size, and with me in a weak state as I had been ill on the journey from North Africa, I put him on my shoulders and staggered up, twice stopping because the Germans ordered me to do so but I was determined not to leave him. I got about 50 yards from them and they started swinging this machine gun and I said, 'Tom, I'll have to leave you,' and that was it, I was a prisoner.

We were put on a half-track and taken behind the German lines way up in the mountains. We stopped halfway up and two or three German officers got out and sat on the grass, had a picnic with huge maps spread out in front of them. One of them said to me, 'Sit down here, Sergeant,' so I sat down and he said, 'Where have you come from?' I said, 'I don't know, sir.' He said, 'What regiment are you?' I said, 'I don't know, sir.' He said, 'Which ship did you come on?' I said, 'I don't know, sir.' He said, 'How many men did you command?' I said, 'I don't know, sir.' He started laughing and said, 'You don't know much Sergeant, do you?' And I said, 'No sir.'

We continued our way up the mountain and as we drove past three old ladies with sacks on their backs, the half-track suddenly stopped again. The German officers made the ladies put the sacks down and they were made to give us what was inside: loaves of bread. The officer then told us to go and get some grapes from the orchard that we had stopped next to.

We arrived at this great big field full of American prisoners; we were the only British. We were taken off the half-track and marched a few miles up the road until we got to a railway station where we were loaded into very crowded boxcars. We arrived at Brenner Pass (a mountain pass through the Alps which forms the border between Italy and Austria). They flung open the doors, shouting 'Out, out', and I fell 6 feet on to the concrete floor; I reckon they must have been SS guards. We were given some soup and stale bread, and they put us back on the train and we next landed in Moosburg, Germany, and we were put in camp there for several months. Being a Sergeant, I was put in charge of

the burial party. The allied Commander in charge asked, 'Would any of you Sergeants like to go to a working camp?' 'Not bloody likely,' I said. 'No, you won't have to work, under the Geneva Convention all the Privates and Lance Corporals have to go to work, but we want you to go as liaison officers between our troops and the Germans.' I asked, 'What advantage is that to us?' and he replied, 'You would get extra rations.' So I volunteered. Everything seemed to be going well. We would organise concerts and buy German beer, which was well watered down so our soldiers would not get drunk. I would go and collect the meals from the kitchen – one loaf for twelve men, which had to be carefully measured. I saw fights over crumbs that had been left.

So with the Russians coming in from the east and our lads from the west, they marched us out the camp. Six weeks on the march; fortunately for us it was spring.

I said to the lads there was a good chance of us getting out. We were split into thousands – a thousand prisoners then a space, then another thousand, and so on. I told my lads, 'If we get to the front of our thousand, as we go over a hill we'll dodge into a hedge.' We tried three times; on the third we saw this path leading up to a wood. The guards were old, as the Germans were losing so many men, so I said, 'The old boys won't see us.' We crept up the path and found a deep ditch 200 yards from the road and the ten of us jumped in and crouched down. I could see they were all just finishing their ten-minute break. They got up but they all stood still and up the path came six guards and the German

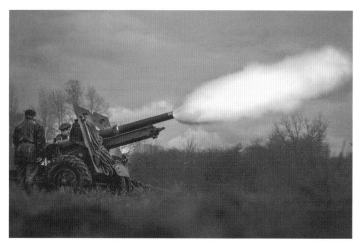

Commander. I said, 'All right lads, down with your trousers and squat!' So we were all there with our bare arses out and the German Commander approached the ditch and asked, 'What is this?' I told him 'Diarrhoea, diarrhoea.' He replied, 'Don't drink water on the march,' and we joined up with our thousand on the march again.

We tried to escape again into the woods but it was very small and sparse and shots were fired, so

we fell to the ground. There was a lot of shouting and firing; one shot just missed my head and went straight into a mess tin that was on a bloke's back in front of me. We put our hands up and Germans took our dog tags, hit us in the back with their rifle butts and made us stand on every ten-minute break on the march.

All we got to eat was bits of stale bread with a bit of grease and the occasional bit of hard beef. On one occasion we stopped outside a farmhouse and I went into the barn and saw this huge pile of potatoes. I thought, 'I'll have some of them!' I took off my cap and started to fill it up, then all of a sudden there was a great big kick up my backside and I went halfway up this pile of spuds and back again! So I was up with my fists and the biggest German I ever saw in my life stood there with a pistol in his hand. My temper soon cooled when I saw his pistol and he made me throw the spuds back.

The next day the guards disappeared because they heard that our troops were in the next village. Over to one side we could see our tanks approaching. There was great excitement, everybody was cheering, but they said, 'Sorry boys, we can't stop but make your way back that way.' A couple of days later our blokes caught up with us and that was the end. We were free men.

Three weeks after the end of the war we flew home in a Lancaster bomber. I was fortunate to sit in the tail-gunner's position just as we crossed the south coast and we actually flew over the John Dickinson factory where I had worked before the war. We touched down in Aylesbury and I was most embarrassed to actually fall out of the plane into the arms of a very pretty nurse. I was filthy; my uniform was very dirty and smelly. The WAAF (Women's Auxiliary Air Force) girls had very kindly organised tea and food in a hanger once we had gone through the cleaning station! It was a very emotional homecoming, with my father running down the road in his carpet slippers to meet me.

I eventually went to live with my sister and while there I went out one night, August Bank Holiday Monday in fact, and I met a girl who was to become my wife. I married Betty on 10 June 1946. I continued with my work as an engineer at the John Dickinson factory. We both became keen on motorbikes, so in 1959 we decided to travel through France, Spain and then into Salerno. The airfield which we were supposed to have taken on the invasion of Salerno was now one vast cemetery – 3,500 of our boys are buried there. The tobacco factory where we were held down by sniper fire was still there. Since then we covered every country in Europe on our motorbikes.

I saw a bit of action but not as much as some of my mates; some of them went through hell.

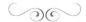

VERNON JONES

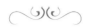

I am Vernon Jones. I was born on 5 June 1923 in south Wales and I am the son of a miner. I came to England in June 1931 and went to school in Abingdon-on-Thames Oxfordshire. I left school in 1937 at the age of fourteen.

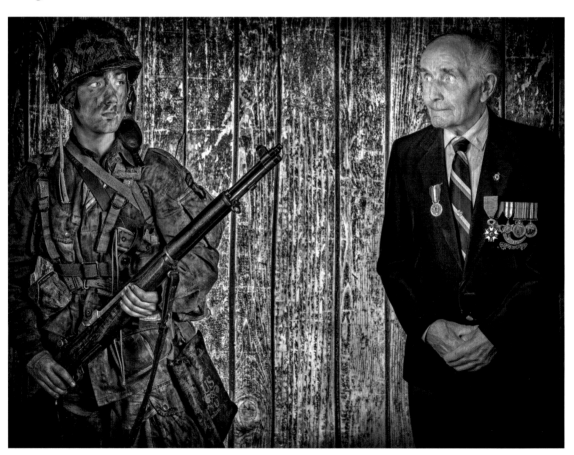

War was brewing, we knew by 1938–39 things were not going to be so good. I joined the Home Guard when I was sixteen and was called up when I reached eighteen. I joined the 1st Battalion Oxfordshire and Buckinghamshire (Ox and Bucks) Light Infantry Division on 29 January 1942. I was then transferred to the 2nd Battalion Bedfordshire and Hertfordshire Regiment, which was called No. 9 Beach Group. We were preparing for D-Day.

On 31 May 1944 we moved from Scotland down to Southampton, ready for D-Day. I boarded a boat in Southampton Docks and stayed there for five days. D-Day should have been on my twenty-first birthday but it was cancelled because of bad weather. So I spent my birthday waiting to land on the beaches of Normandy, which was not very pleasant. On 6 June I landed on Gold Beach, near a village called Ver-sur-Mer. We were the logistics who helped make the beachhead and stay in position to help unload ammunition, petrol and food. We stayed there until July when the floating dock *Mulberry* arrived at Arromanches. We were then asked where we would like to go and I said I would like to join my old battalion, the Ox and Bucks Light Infantry. I then fought with the Ox and Bucks through France, Belgium, Holland and on to the Battle of the Bulge in January 1945, then into Germany and I fought in the Reichswald Forest, which was one of the biggest battles of the war. I was wounded in the forest on 14 February 1945. It was not too serious but I had three weeks out, they patched me up and I went back again to the crossing of the Rhine. We crossed the Rhine, up into Germany with some bitter fighting but I survived. We finished up on 4 May in Hamburg. I carried on in the army after the war, and my job was to work with displaced persons and help them get repatriated.

I met this Russian girl; she was much older than me. It was only a platonic friendship. Before she went back to Russia we said we would write to each other but it never materialised. She was such a nice woman who suffered many years in captivity in Germany.

I went to a Polish wedding of a displaced person I helped. I actually drove them in an ambulance to the wedding. I stayed for the reception but I do not remember anything until the next morning because I had been drinking so much I passed out! I woke up and thought, 'Where have I been?' Believe it or not, I had been to a wedding!

On 18 December 1946 I was discharged and went from Hamburg to Hull to York where I was de-mobbed and from there I came home to Drayton, Oxfordshire where my parents were living. I went on to work at the Harwell Atomic Energy Authority for forty-three years until retirement in 1988.

At my retirement, they threw me a small party, my boss gave a little speech and he said, 'I'm going

Army Form B. 104—81A.

No. Cas/621.
(If replying, please quote above No.)

St. JOHN'S HOUSE, *Infantry* Record Office,
WARWICK.
23rd February 1945

Sir or MADAM,

I regret to have to inform you that a report has been received from the War Office to the effect that (No.) *5392932*

(Rank) *Pte*

(Name) *JONES. Vernon*

(Regiment) OXF. & BUCKS. L. I.

has been wounded, and was admitted to *in the hest European theatre of war*

on the *14th* day of *February* 1945 The

nature of the wound is *sprain right ankle (Bullet wound)*

I am to express to you the sympathy and regret of the Army Council.

Any further information received at this office as to his condition will be at once notified to you.

Yours faithfully,

Officer in Charge of Records.

IMPORTANT.—Any change of address should be immediately notified to this Office.

(59900) M22156/1356 500m. P.&G. 10/39 52-4101 Forms/B.104—81A/3

to surprise you all now, I know none of you know this but Vernon was one of our D-Day heroes,' and everybody looked flabbergasted. I never told a soul in the forty-three years I worked there.

I then took up bowls and I am still playing it and I have kept good health right up to this very day.

There were good times and bad times; very happy times but very sad ones as well. I lost my best friend in Germany on 14 February 1945; we were good pals together and we were going to do wonders when we got de-mobbed but it never materialised. Poor George never made it. I enjoyed my time in the army to a certain extent, but the army was not my choice. If it had been left to me I would not have gone into the army because I would never have thought about joining it as a regular soldier. I was a plumber by trade and the army did not come into my vocabulary at all.

Today, I am very happy as I am. I have a good wife (Hilda), I am fit, I have no worries financially or otherwise, so I am quite content in my old age. I do not worry about dying – when you get to my age you never think about it, you just carry on with life and enjoy it.

REG CHARLES

My name is Reginald Charles and I was born on 1 February 1923. In January 1942 I was called up and joined the Oxfordshire and Buckinghamshire Light Infantry. I went in as a Private and came out as a NCO–Corporal in April 1946.

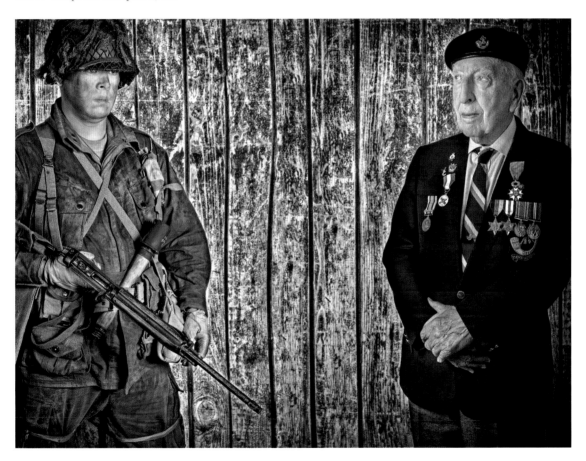

I had five months' training in Oxford and was transferred to the 5th Battalion Oxfordshire and Buckinghamshire Light Infantry, which was stationed in Northern Ireland. Eventually we moved to Colchester for training for the D-Day landings. We trained to waterproof vehicles so they could be driven off the landing craft into the water. The problem was they had to breathe like us but we still had to protect all the electrics. The vehicles would only drive up the beach a quarter of a mile and then you would have to remove the waterproofing kit.

We were actually based in Ashford when we heard that the D-Day landings had taken place. I was in the transport section running the stores for the battalion and sorting out the vehicles that had been burnt out on the landing beaches. I was very fortunate; I was left behind.

Three weeks later I was on board a troop-carrying ship on my way to France. I joined up with the 1st Battalion, which was already in action 10 miles south of Caen. After the Caen area was captured, we advanced to Falaise and took the village of Pierrefitte. We were then re-equipped and our numbers brought up to a decent strength because we got down to half the battalion strength. We pushed on through the Falaise Gap up towards Belgium.

After marching 20 miles per day, mopping up German snipers that were left in woods and churches, we finally arrived in Antwerp ready for Operation Market Garden.

After Market Garden, Christmas 1944 was a welcomed relief. Unfortunately we received our orders to move out in the morning. We were to go into the Ardennes – The Battle of the Bulge. We travelled in modified Sherman tanks with their turrets removed and used as troop-carrying vehicles.

My task when we arrived was to supply food for the whole platoon in one single jeep! My supply route was through the forest, which was mined. A track had been cleared just wide enough for the jeep to get through and had been marked by white tape. White tape against white snow really did not work, so I had steer with one hand with the other on the tape. I would go back and forth for a number of nights, dropping off food and returning with the casualties.

We then progressed up into the Reichswald Forest. At the beginning of February 1945 General

Montgomery thought it was the right time to attack because everything would be frozen hard and we should be able to break through the forest and the Siegfried Line in record time; it just did not work out that way. The first four days in the forest, it rained and rained and rained. We were nearly up to our knees in mud and we could not get any supplies through. We eventually managed to get some very small-tracked

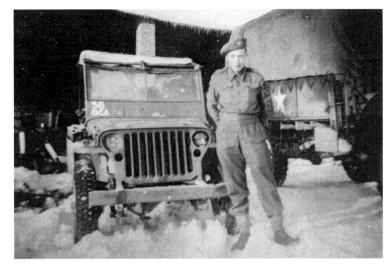

vehicles called Weasels, which brought us food and ammunition. If it was not for them, I do not think we would have survived.

We advanced through the Reichswald Forest and reached the Siegfried Line. The Germans had no protection to the rear of the Siegfried Line; they only protected the front. Our twenty-five pounders destroyed the rear and we really walked through.

We progressed to the Rhine crossing, then Bremen and we were the told we would have to fight for Hamburg. Fortunately we did not. It was declared an open city on 4 May 1945.

We moved into Berlin and our task there was to guard Rudolf Hess. I stayed in Berlin for three months, came home on leave and never returned. I was released from the army in April 1946.

I married June in 1954, had a son Ian in 1957 and a daughter Sheila in 1959. I now have six grandchildren and twelve great grandchildren.

I try to get over to Normandy every year to visit, and the beauty of it is that our families are also interested; it is good to keep the interest going. With the Internet, it is good to make new contacts and meet so many veterans in Normandy every year.

ALAN GULLIS

My name is Alan Gullis and I was born in Wiltshire in 1925. I was called up in 1942 and joined the Royal Army Service Corps; I worked on the Mulberry Harbour at Sword Beach, Arromanches, Normandy, taking supplies on and off to the units.

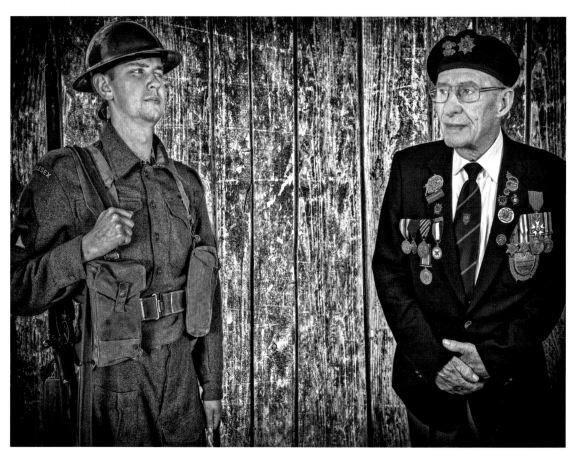

One of my main duties was to make sure the supplies were correctly designated for the Bayeux Bypass. The Royal Engineers had to gouge a cut-through, five lanes wide because Bayeux was a priority to capture to save the cathedral and its tapestries. The jeeps we supplied carried 240 jerrycans of fuel on board, so we were thankful that we had Spitfires flying above to give us air cover. Once the advance had moved up, my unit went inland seven miles to be told it was to be disbanded!

I was eventually assigned to a Regimental Police unit heading for Lille, as it was short of men. We then progressed into Nijmegen, Holland, for the big river crossing. I was then given a new posting as a driver for a Captain from the Army Catering Corps. I drove him all the way to Berlin, as he was in charge of catering for Churchill's Mess at the Berlin Potsdam Conference in July 1945. I had a few

skirmishes with the Russians on the other side of the Brandenburg Gate; they had a nice little black market!

The Captain was then promoted to Major and was assigned as the Catering Officer for the Town Garrison in Hamburg. I drove him up to Hamburg. He called me in one day and said, 'I've got a decision to make, it would appear your wife's in a bit of trouble at home, and you have to be sent home.' He had a warped sense of humour and he quickly added, 'because of all the demobbed going on, there are a few units here that are short of drivers – no, go pack your kit, I'm sending you home'.

I had married Edna a month before D-Day and met her with open arms at the train platform. I was given a week's leave and then started work. Before the war I worked on the overhead electricity lines and the Government was pushing to get all the village street lighting again after being in the dark for many years. I left in 1947 after that really cold winter. I remember it was raining ice and we had to chop ice off the poles! I got the driving bug back again and got a job as a driver with the RAF and it was not long before I got my calling-up papers for Korea! Because I was working in the RAF, the Flight Sergeant said, 'take your papers and go up to Headquarters, I will ring them up and tell them you're

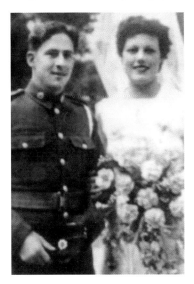

on your way'. The officer in charge at HQ said, 'I hear you've got a piece of paper, what do you want me to do with it?' I replied, 'Well I won't actually tell you but you've got a good idea and you can flush it away afterwards.'

In 1949 I joined the local TA band. I remember being on parade and the Staff Sergeant suddenly ordered me to stop playing and said, 'You look old enough to have been in the last war, where are your medals?' I replied, 'I don't have any, sir.' I did not have any discharge papers because of the way I was sent home from the army with a special pass to be with Edna, but I did eventually receive my medals some time later. I continued with the RAF, then left to drive coaches all over the country for a local firm until my retirement. We had two sons and one daughter. Edna and I are still going strong and enjoy attending various veteran get-togethers around the country.

BILL PENDELL

My name is Bill Pendell, I was born in 1921 and I joined the Royal Signals 11th Armoured Division. On 6 June 1945, I landed on Gold Beach, Normandy. I clearly recall the intense sound of gunfire, but luckily the worst of the fighting on the beach was over by the time I arrived in the afternoon.

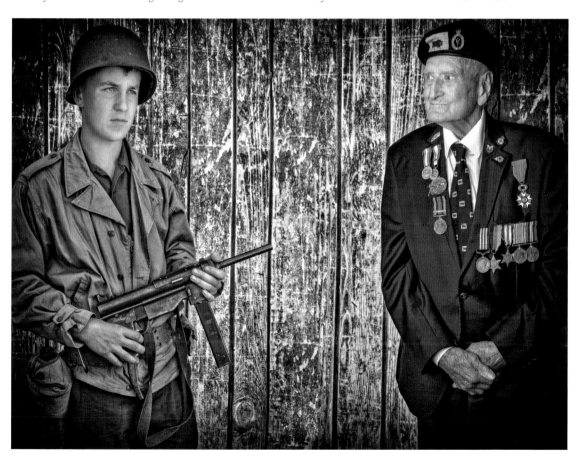

I served under the command of General 'Pip' Roberts, mostly doing despatch riding at night between group and front line units. It was my job to explore enemy troop movements and positions. I was always on my own. I only had a Sten gun as a weapon but I hardly used it as otherwise I would have betrayed my position.

The first of my friends in the troop to be killed was Ivor Griffiths, a married bloke with three children. That upset us all. All the boys collected and looted as much money as we could find and sent it home to his wife in Swansea.

Throughout the Normandy Campaign, I was busy delivering vital messages from one unit to another on my motorcycle, often traveling through minefields or difficult terrain and sometimes behind enemy lines. I enjoyed working alone and living on my wits; I don't know why, I never thought I was in danger. I knew I had to do something and I did it and that was that. Then I'd have a cup of cocoa! As a Dispatch Rider I was in a bubble. I didn't think like a soldier. I was just an ordinary bloke and I had to look out for myself.

On 15 April 1945 we were then given the unpleasant task of liberating the concentration camp at Bergen-Belsen. I was with the forward unit on the discovery of the camp and clearly remembered seeing the tall wire fences just ahead and people on the other side eerily staring through at us. We were ordered to withdraw for fear of spread of disease. I really do not want to talk about that.

I was awarded the Military Medal for delivering every single communication without fail.

After the war, I started my own masonry company in Oxford and built my own house and haven't moved since.

LEN FOX

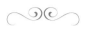

My name is Len Fox and I was born on 8 January 1925. I volunteered to be a dispatch rider in the Royal Army Service Corps and did my training in Aldershot.

Not only were we trained to ride a motorcycle, we were also trained to fall off it! We used to go round

and round a field at 15 mph and when the instructor dropped his flag, we had to lay down the bike. I passed all my tests and I was ready for the invasion of France.

I was nineteen when I went over on a Liberty ship on D-Day. It was very rough, fifty of us down in the hold being seasick and the smell was terrible. We climbed from the ship down a rope ladder on to a landing craft. We landed near Arromanches on the Gold Beach and as we ran inland and we could hear the Beach Master shouting, 'Get your arses off the beach as fast as you can.' It was about 6.00 pm and we were still being shelled by German artillery. I saw a German helmet land on the sand and I nearly tripped over it. When I looked down it still had a head in it! Then I realised what war was about, seeing a man's head in a helmet – that really shook me up. We managed to keep going but our ammunition truck got a direct hit – nothing left of the driver or his mates and all that is buried in Bayeux Cemetery are their dog tags. We entered Bayeux at one end of the street as the Germans were pulling out from the other. My job was to lead a convoy of trucks full of ammunition. I got to the crossroads at Tilly-sur-Seulles, south of Bayeux, when the Germans opened up their 88s on us. The leading truck got hit, I got blown up in the air off my bike and I was semi-conscious lying on the road and completely deaf. The stretcher-bearers appeared, laid me face down and took me off to a Casualty Clearance

Station. The doctor appeared with a big pair of garden shears, cut off my uniform and said, 'It's good old Blighty for you, young man.' I was put on to a hospital ship and ended up in a hospital in Maidstone where they took shrapnel out of my spine. I also had one piece go through one buttock and out the other; I think I am the only man with dimples on his bum! Six weeks' sick leave and I got back over there just in time for the liberation of Brussels.

I was promoted to Sergeant. As we made the

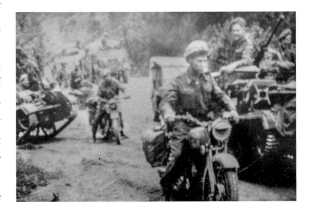

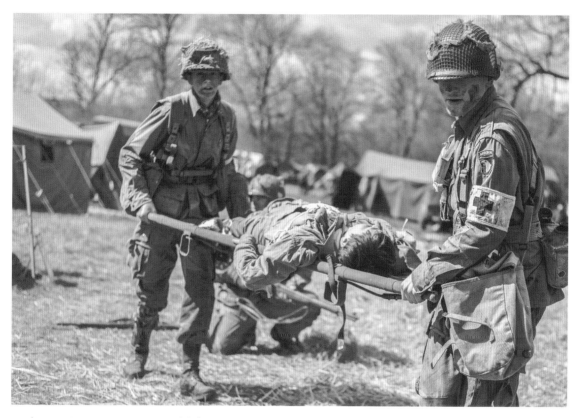

push into Germany we were told the war was over. I was then ordered to report to a BB Camp, which I thought meant a DP Camp – a Displaced Persons' Camp in Hanover. I was given a map with reference points and escorted a truck convoy. It turned out to be the Bergen-Belsen Concentration Camp. Even today I cannot talk about it: the sights, the sounds, the smell of Bergen-Belsen is still with me to this day. I cannot understand how human beings can treat other human beings in such a disgusting way.

I spent a further two years in Germany and then came out of the army. I married and had two girls and a boy. I got work as a lorry driver for Unilever and took early retirement because my back got sore due to my war wounds.

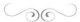

ARTHUR BAILEY

My name is Arthur Bailey and I joined the army in 1942 when I was eighteen years old. I was a wireless operator in the Yorkshire Division. I was told, 'join the Paras, you'll live for ever', and I am keeping my fingers crossed.

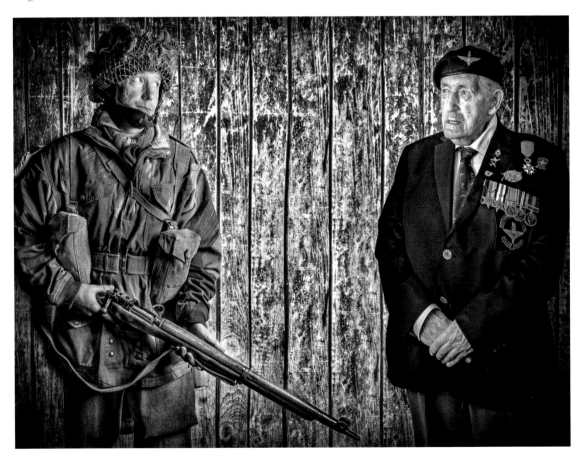

We were all fed up in England by 1944; we had been smashed to pieces by bombs every night. All we wanted to do was to find a way to get the war over.

Normandy D-Day+1; I landed on Gold Beach at 7.00 pm, and that is why I am here today to tell the tale. The first wave of troops who went on D-Day took the first attack to the Germans, who were waiting for them. There were so many of us, we could not all be sent across in one day. We left the next morning and when we got as far as The Needles, Isle of Wight, we were all asked if we wanted to write a will. Then I knew we were in for something big. I was in the Royal Signals; if I had been in the infantry, I probably would not be standing here today!

The first town we took was Bayeux, which was in fact the first town to be liberated on D-Day. We went on to Le Havre in August, which was a big battle and I had a few near misses.

We met General Montgomery, our Commanding Officer, and he wanted to capture the bridge over the river Rhine in Arnhem, in Operation Market Garden. He ordered us to rush up to the bridge. We were told there would be very few Germans, as they were all on the run. We got there and found two Panzer Divisions and 70,000 Germans! We dropped 10,000 Paras and lost 8,000 – they were killed, wounded or captured. The fighting was fierce, it was not very nice in spots and I never thought I would come home. Even today I still do not know how we managed.

We need to remember Arnhem. Unfortunately, it looks as if there will always be wars.

After the war I settled down into civilian life and became a baker.

JOHN SLEEP

My name is John Sleep and I was born on 26 January 1921 at 1.30 am. I volunteered in 1940 and joined the Royal Berkshire Regiment and then the Parachute Regiment.

I was stationed at brigade HQ when our new Brigadier arrived and as he watched the Sergeant

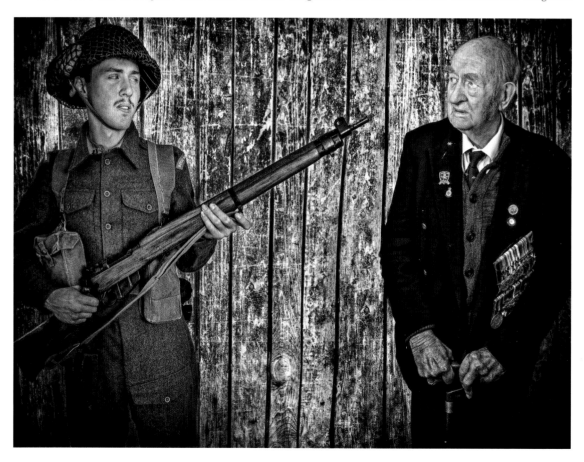

Major drilling us all, he shouted, 'What are you doing Sergeant Major?! Are they going to trample the bloody Germans to death?' He did not want any clockwork soldiers. One night the Brigadier spotted a sentry on duty at the front gates and quickly shouted, 'A German raider can pick you off straight away, in future hide in the bushes.' That suited us fine, as we could have a fly smoke!

I then shipped out to Algeria, on to Libya and then into Tunisia. I took part in the Battle of Taranto in November 1940 against the Italian naval base. A group of us were then sent up to the Italian town of Bari to persuade the Italians to work for us because the ships in their harbour were full of mustard gas.

I joined Operation Overlord on D-Day+4 on a supply ship. We were put down into the hold, which was all right in the harbour, but once we set off it started to roll and we were all bumping into each other! Everybody lost their tempers, banging at the hatch. A young officer came and opened the hatch and ordered us to be quiet, but it was too late. We all scrambled up out through the hatch and told him if we had to go back down into the hold, he would be swimming!

We worked our way through Normandy and then up into Belgium. I remember seeing this house in the middle of a forest, so I left my Bren gun with my number two and I set off to see what I could scrounge. I entered the house and saw two Belgian soldiers lying dead on the floor. As I looked down, I heard a bolt being drawn on a rifle. Next thing I knew, there was someone standing by my side; he was a German. He looked at the two on the ground, turned to look at me, and walked away. He was probably the rear guard from their main column; it was my queue to leave.

After the Battle of Arnhem in September 1944, I was medically discharged. I then started a business making gymnastic equipment, which was quite successful until some bastard burnt it down!

I married and had two girls, and enjoy going to all the veteran reunions to catch up with my old mates to remember and to pay my respects.

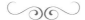

STAN WRIGHT

My name is Stan Wright and I was born in 1924. I joined the Royal Army Service Corps, but then volunteered for the Parachute Regiment and did my training at RAF Ringway, which is now Manchester Airport.

I was then posted out to Burma and returned back to England in 1944 for Operation Market Garden. I made the jump into Arnhem on 17 September 1944. We landed but could not get any further, so we had to withdraw and I swam back over the river Rhine, exactly like in the film *A Bridge Too Far*. I made it back to England, only to be posted out to India.

I came out the army in 1947, married and got a job at Lucas Industries in Birmingham as an engineer. I spent fifteen years at Lucas's and then moved to the packaging department at the Post Office, which was a smashing job, and I eventually retired. I have now just moved into sheltered accommodation.

I regularly attend the World War II veteran events, especially Arnhem. I have been going back every year for the past thirty years.

I really do not like to talk about the war.

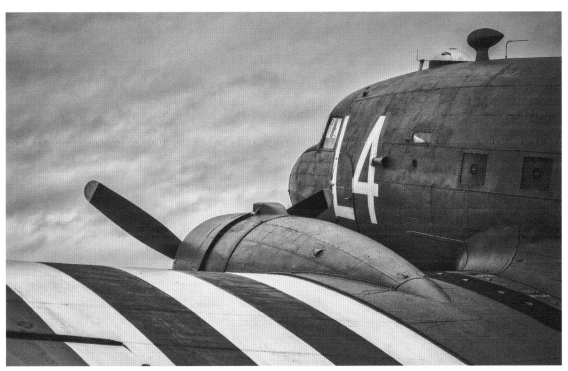

ERIC STANMORE

I am Eric Stanmore, I was born in 1927 and I joined the army in February 1945 at the age of eighteen. I did my basic training in Colchester and then joined the Parachute Regiment, and went into the newly formed 17th Battalion in March 1945. My first posting was on the Isle of Wight, after which I was sent

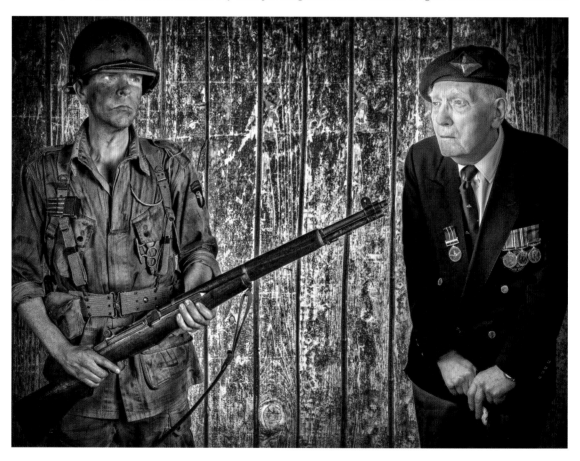

back to Hardwick Hall in north Derbyshire for more parachute training. I made fourteen jumps: eight in basic training and six spaced out throughout the war. We needed to make the jumps to receive our parachute pay.

I was demobbed in January 1948. I wanted to come out because I did not think I would make a good peacetime soldier.

I then got a job as a Blackpool tram conductor. The local Grammar school kids would often come on the top deck and I used to help them out with their maths homework but then word got out so there would be large groups of children wanting me to do their homework! This was what was missing in my life, so I moved down to London and got involved with the Government Training Centre. I eventually got a job as draughtsman designing rockets with the Fairey Aviation at Heston Airport, west London. I spent forty years in the aircraft industry.

I got married and have three children.

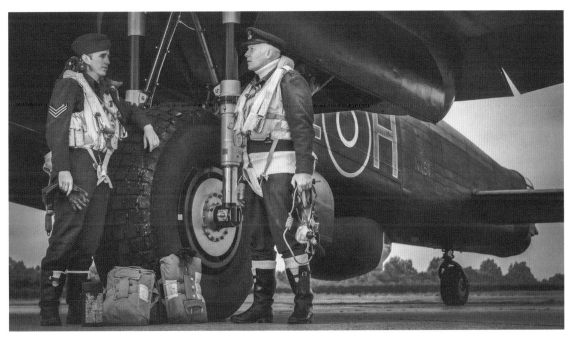

TED HUNT

I am Ted Hunt. I was born in 1920 and my family were watermen and lightermen on the river Thames. Watermen carry fare-paying passengers and lightermen carry cargo. I have done both under sail, under power and under oars.

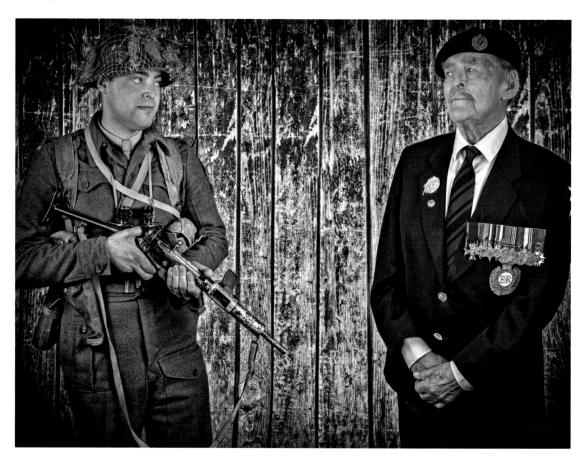

I joined up in 1939. I learned that nineteen was not old enough, they would only take twenty-year-olds, so I added half a year to my age and was immediately sent to Field Company Royal Engineers, part of the 49th West Riding Division. Within six months I was on my way to Norway. The Germans had invaded Norway, just beating us to it. What was precious about Norway? It has the Arctic port of Narvik, which is warmed by the Gulf Stream, so it does not ice up. Also, Sweden's iron ore was put on a train and then on ships at Narvik – the Germans wanted the iron ore and we wanted it. The Norwegian campaign was a very miserable affair for us, as we were not ready for it and the Germans were far better trained than us.

My field company had the job of making an airstrip. We joined fourteen separate fields and it was only when the Hurricanes arrived towards the end of May 1940 that it was felt that the Battle for Narvik could begin.

We captured Narvik on 28 May and much to our surprise we were given the orders to do as much damage as possible. We found this difficult to understand. What we did not know was that things were looking very serious in Dunkirk and it was likely we would be needed home.

We sailed back to the Clyde, Scotland. Our company then went on to build an anti-tank ditch right across Fife from Kirkcaldy to Newport. We moved down to East Anglia and prepared the place for a German Invasion. Depth chargers were put at each end of bridges which later would be demolished and the depth charge would make the gap so much wider to make it more difficult for the enemy. We then put charges on petrol tanks in Purfleet below ground and set up machine-gun posts throughout the Essex countryside. It was summertime and it was good to be in company with fellow sappers with whom we had endured battle in Norway.

The War Office then had thoughts about invading the continent. They approached the Company of Waterman and Lighterman. I was to join the Inland Water Transport Company Royal Engineers with the prospect of learning how to handle invasion craft up in Stranraer, Scotland.

Special craft were built for the invasion; they were called Rhino ferries. Each one was made up of 180 separate boxes, so it was unsinkable. It was a large floating platform with 7,000 square feet of space, 180 feet long, 42 feet wide and a ramp at the front with two engines at the back which made them highly manoeuvrable. We learned how to handle them on exercise on beaches on the Isle of Wight and in Devon.

We boarded our ships and then prepared to be towed across the Channel by the landing ships for D-Day.

I was commissioned as a Captain and commanded fifteen Rhino ferries on Gold Beach on D-Day.

We knew the Germans would expect us to rely heavily on landing ships and to arrive bang on high waters, spring tides only. It would be impossible for landing ships to beach and get rid of their cargo at any other time. Our lot had decided that Normandy was the right place to go because it was not as heavily defended as Calais, which was ideal for landing ships. The decision was made that the LSTs (Landing Ship, Tanks) would only beach when the beach was under fire and the few days it was under fire – the last mile would be done by shallow vessels and the Rhino ferry was by far the largest and could carry fifty vehicles and put them ashore in 2 foot 6 inches of water.

We arrived on Gold Beach on D-Day morning and we could see the beach had been fixed with pit props – 70,000 had been put there by Rommel, convinced the attack would come at high water with mines attached to the end of them, ready to blow up the bowels of any landing ship. So we arrived four hours before high water and that is why we could see them, up in the dry. Brave sappers went ahead of my company and cleared pathways wide enough to take my Rhino ferries, which were 42 feet wide.

We carried on through D-Day not without loss. Some of the mines from the pit props had come loose from bad weather and were lying in and around the sand. Three of my Rhinos were hit, which created large holes, and many of the connected floating boxes that made up the Rhino disappeared. But all the ferries were still afloat, so my men carried on with a big hole in the middle. Half the LSTs on Gold Beach were American and when they saw the Rhino about to take their cargo with a great hole in the middle, they said, 'Brother, have you been in trouble?' Of course national rivalry came into play and I replied, 'Oh, you should have been here the first day!'

When the beach ceased to be under fire, the landing ships would come in almost at any stage of the tide to unload their cargo.

One of the most morale-raising matters that I saw on D-Day was the care of the wounded. Sergeant Sheppard was wounded in the early hours of D-Day with shell splinters in his back. He was taken to a Casualty Reception Station, put on a stretcher with a label attached to describe his wounds and needs, and put on a DUKW boat. One of four of the ships that landed on Gold Beach on D-Day were called

Hospital Carriers and came over with male nurses and surgeons of the Royal Army Medical Corps. Sheppard arrived back in England on the afternoon of D-Day. Ninety thousand wounded men returned on the tank decks of an LST.

Altogether we had sixty-four Rhinos and in four months we had put ashore 93,000 units containing vehicles, tanks, guns and 440,000 tons of military stores – everything from explosives to bombs to toilet rolls – everything that the army would need and without those things wars are lost.

I later found out more people drowned on D-Day than were shot. This did not surprise me as so many DD (Duplex Drive) tanks, with the skirt that was supposed to keep them afloat, drowned – so many brave tanks crews that we could ill afford to lose.

I eventually moved into Holland where there were so many rivers and canals to cross. I was asked to give advice to the Chief Engineer of the 2nd Second Army. Fortunately for us, a very brave Dutchman called Lambrechtsen van Ritthem, an engineer of the Dutch State Waterways, joined the British Army. If I had been captured by the Germans I would have been a prisoner of war; if he had been captured he would have been shot as a terrorist, as his country had given in. We both designed the longest floating Bailey bridge of World War II that crossed the river Mass. The bridge was 4,008 feet long and was opened on 19 February 1945.

By now I had been promoted to a Major and was sent back to England after VE Day to get prepared to take my company to Burma.

Traditionally the last man in the company to have embarkation leave is the OC (Officer in Command) and indeed when I was on embarkation leave they dropped the Atomic bomb. It was a matter of waiting to be demobbed. Everyone was given a demob number, which was based on length of service and age. Eventually, demob group 27 came up and I was demobbed in May 1946.

I married and had two daughters and one son. I returned to civilian life as a college lecturer in navigation and watermanship in London until 1985.

In 1978 I was invited to become the Queen's Bargemaster. The Bargemaster is responsible for getting the royal crown to Parliament. Each year for twelve years I had the great pleasure and delight of holding the Imperial State Crown in my hands for Her Majesty to wear as she arrived at Westminster. The Queen honoured me by making me a member of the Royal Victorian Order, her personal gift.

I spoke to ten-year-old girls from the local school on Armistice Day in 2017 and they asked, 'Why do people drop bombs on people?' I did not have the answer; I still do not.

ERNIE TAYLOR

My name is Ernie Taylor, I was born in 1923 and I joined the RAF in 1941 as an eighteen year old. I was sent to Scarborough to the ITW (Initial Training Wing) and then went on to Flying Training School. We started flying in Tiger Moths, which were beautiful biplanes, standard for training pilots.

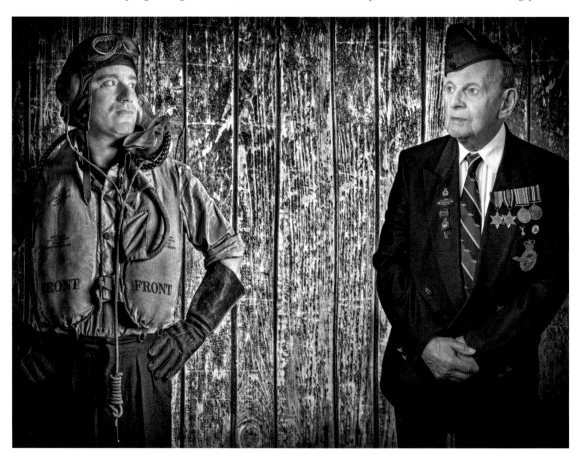

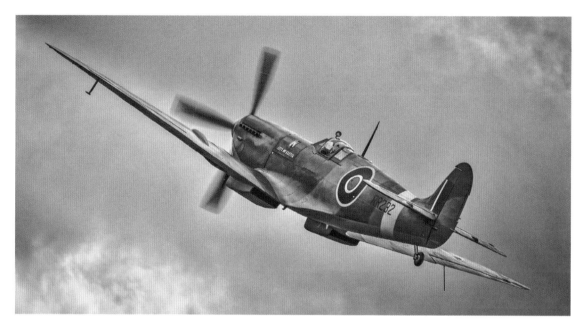

I really wanted to go into Bomber Command, as I wanted to get back at the Germans for bombing our cities! I was refused, as I had been only trained on single-engine aircraft.

I was then moved on to the American Avro for further training and finally I got on to the Hurricanes. We were taught using a camera gun, then proper air-to-air guns using a live target. The live target was another plane – he was a brave target!

I was sent to No. 30 Squadron, where we were fitted out with Spitfires and posted to the Far East, India and Burma.

Near the end of the war I contracted malaria and was sent to hospital. I recovered and was posted to Karachi, which is now in Pakistan. I was a test pilot and I flew many planes that were brought over from England and America, including upgraded Spitfires, Tempests and the American Thunderbolt.

I left the RAF in 1947. I applied to many civil airline companies as a pilot but was refused. They told me I was a single-engine pilot, so to train me for multiple engines I would need to go on a course, which would cost them money. So I ended up in advertising and publicity.

I married and have four children.

WILLIAM TAIT MOORE

My name is Bill Moore from Scotland and I enrolled in the RAF in 1941 at the age of sixteen. I joined the elite Air Observers School in Canada for ten months' training and then I joined 138 Squadron and flew men and woman from the Special Operations Executive (SOE) into France and other parts of Europe.

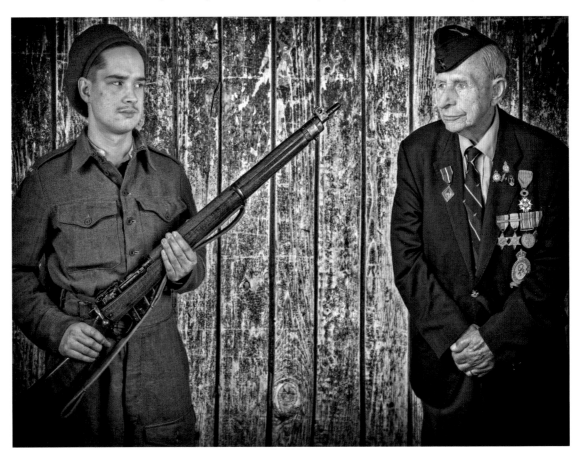

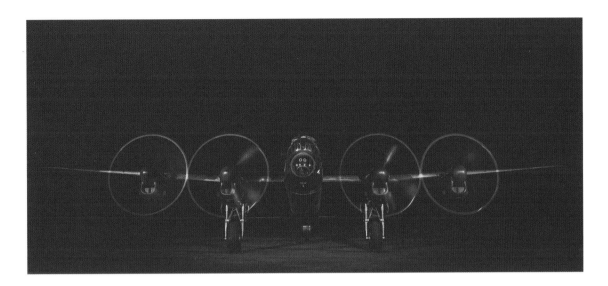

It was a secret business, one of the most secret businesses in the RAF at the time. We called ourselves taxi drivers. We took the SOE agents to various places and sometimes we picked them up too, but not often. The one thing we did not do was communicate with them – we kept our distance. The less they knew about us and the less we knew about them, the safer it was for all of us.

By 1944 we were flying Lancaster Bombers and Wellington Bombers, dropping arms and ammunition to the Maquis, the French resistance fighters.

In 1945 I was involved in Operation Manna, a humanitarian mission to drop food into the Netherlands. It was a gentleman's agreement set up by two Canadian officers and the German High Command. We took the food in, which the Germans wanted as well as the Dutch people. They were completely starving.

Throughout the war our squadron took in 995 agents, dropped over 10,000 packages, lost seventy aircraft and 300 aircrew.

After the war I flew over Europe, photographing from the skies. I left in 1947, got married, had children and headed into the family's building business. Today I attend the monthly Woking Aircrew Association meetings and I am the secretary for Woking RAF Association.

Our motto was 'For Freedom'.

JACK GRIFFITHS

My name is Jack Griffiths. I was born in November 1921 and in 1939 I ended up in London.

I went along to the navy first. You had to have all your teeth. As a youngster I used to box for the school and I had lost some of my back teeth. It never worried me, I never thought about it, but in the

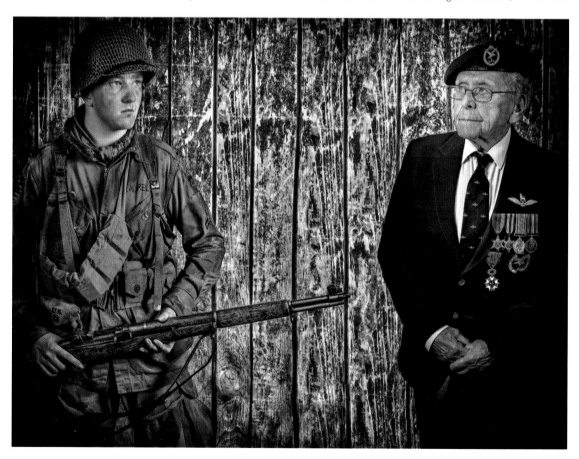

navy in those days – pre-war – they had to be 100 per cent intact. The navy said, 'Sorry, son, you have to have a full set in the navy.' So I thought, 'Well, the army is recruiting in Whitehall,' so I went in there and said, 'I would like to join the regular army.' That was it. I joined the regular army in May 1939.

Nobody had any illusion there was going to be a war. Germany was determined to rule Europe and we knew we would fight her again. People would flock in to join the TA or something like that, so I thought I would get in there and join the regular army, and it was a good move really. I served as a dispatch rider with The Royal Signals in the British Expeditionary Force. I initially failed the maths test, so while stationed near Inverness I asked a local school headmistress to teach me. I passed with flying colours and trained at the Commando Training Depot in Achnacarry. On one occasion, whilst on my motorbike on patrol in the Highlands, I was shot at by a German spy, somersaulted over the handlebars and landed at the bottom of a cliff. I broke my back, but after a few months I managed to recover and continued my training.

After managing to escape from the beaches of Dunkirk in 1940, I went on to volunteer for the newly formed Glider Pilot Regiment, a unit within the Airborne Forces overseen by joint RAF/Army co-operation.

Then the day I was due to go back to London to transfer to America – that is where they were training them in those days – the army said they were losing too many officers for training to America, so as from that moment no transfers, it was finished, so that was it. I got back to my unit again, frustrated, then they asked for volunteers to fly gliders. I was told I would fly powered aircraft first, then in action I was going to fly heavy gliders.

So I went back again, same interview board and the squadron leader said, 'I've seen you before haven't I, twice?' I said 'Yes.' 'What happened last time?' 'I got beaten by the number.' 'Oh god,' he said, 'and now you're going to volunteer to fly gliders and power?' I said, 'Yes,' and he said, 'Well, good luck to you.' I remember seeing

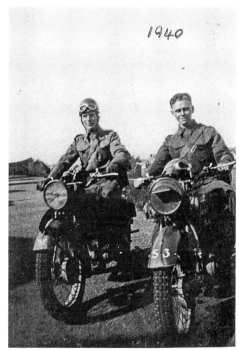

1940

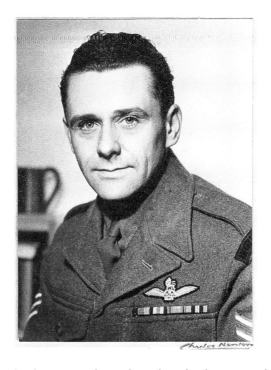

him write down: 'This man will make an excellent pilot,' which was rather nice. He stood up, shook my hand and said, 'Good luck, lad.' It all helps; I was an above-average pilot.

I was very lucky, the group captain in charge of the whole lot said, 'Right lad, I'm checking you to the limit; I will check you on instrument flying. You take off on an old Tiger Moth purely on instruments, you can't see the ground, you can't see anything other than your instruments, and I passed a 1+ on that. So my future was made then. I started on power first then on to mid gliders then heavy gliders – the big one could carry a twelve-tonne tank.

So I got on to those and went into action in the early hours of D-Day and landed in Ranville, close to Pegasus Bridge. Then I got away with that and they brought us back when the army started moving. I then went into Arnhem. Our job was to capture the bridge over the river Rhine and the railway bridge. The section I was leading got as far as the railway bridge just as the Germans blew it. We then tried to fight our way to the road bridge – Jerry was moving fast, he put a full SS Division between us and the bridge. There was no way we could break through to the bridge – that was more or less written off – there was nothing else we could do. The German Commander of the Division was really on the ball, we had met him in Normandy and he was one of their top generals, he moved very quickly. We gradually fought our way back to Oosterbeek; we held on there, nine days fighting from dawn to dusk. Dusk was when Jerry used to push his tanks through. I had a patrol, really good lads they were, we knew we would be captured eventually but we knew that our job was to hold them back as long as our main body could get back across the river. Of course, how do you cross a river like the Rhine, no bridges, you cannot swim. You could have as a young man full of life but we had been fighting for almost ten days then, we were worn out. We were told to hold out till dawn and we were completing surrounded by then by the SS Division who were excellent,

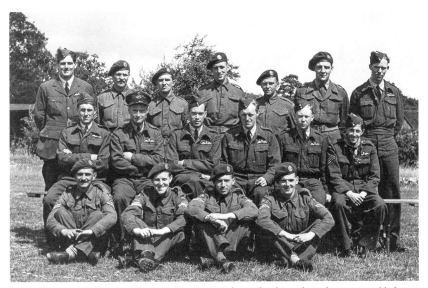

Above: Back row third from right *Below: Third row from front second left*

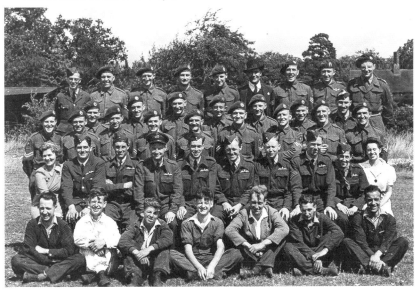

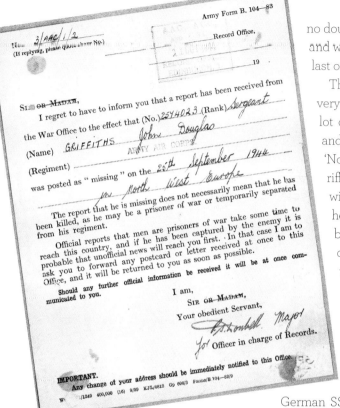

Army Form B. 104—83

Num. 3/AAC/1/2
(If replying, please quote above No.)

Record Office,

19 .

SIR OR MADAM,

I regret to have to inform you that a report has been received from the War Office to the effect that (No.) 2574023 (Rank) *Sergeant*

(Name) GRIFFITHS *John Douglas*

(Regiment) ARMY AIR CORPS

was posted as " missing " on the *25th September 1944 in North West Europe*

The report that he is missing does not necessarily mean that he has been killed, as he may be a prisoner of war or temporarily separated from his regiment.

Official reports that men are prisoners of war take some time to reach this country, and if he has been captured by the enemy it is probable that unofficial news will reach you first. . In that case I am to ask you to forward any postcard or letter received at once to this Office, and it will be returned to you as soon as possible.

Should any further official information be received it will be at once communicated to you.

I am,
SIR OR MADAM,
Your obedient Servant,

G.A. Cambell Major
for Officer in charge of Records.

IMPORTANT.
Any change of your address should be immediately notified to this Office.

Wt. /1249 400,000 (16) 9/39 KJL/8812 Gp 698/3 Forms/B 104—83/9

no doubt about it. By now, I was the lead Staff Sergeant and we held out there to the last minute and I was the last one with a squad to hold it by the church.

The Commander was quite reasonable and in fact very pleasant. He said, 'My God, you cost us an awful lot of casualties.' He said put your weapons down and put your hands up above your head. I said, 'No we bloody don't.' I told my men, 'Reverse your rifles upside down on your right shoulder and we will walk out, I'll lead.' Poor old Jerry had no idea, he stamped his feat and his superior behind him burst out laughing. He saw the funny side but the one who was trying to beat us down did not see the humour at all.

Someone told me that any pilots or paras found with their daggers on them would be shot! Somewhere along the banks near the Rhine there are thirty to forty daggers pushed secretly into the bank!

The Commander, who was the senior German SS officer of the Division asked me, 'Would you like a smoke?' I said, 'Oh yes please.' He replied, 'Do you notice they are Players, we only have the best here.' I said 'Yes, I noticed that.' It was the supplies we had dropped beyond our forward positions – we were not very accurate in dropping supplies and you do not know where you are really. When you are on the ground you can only see the ground and you cannot see people in trenches to see if they are German or British, and so all our supply drops went into the German lines. The Commander said, 'We had masses of British food, drink and cigarettes.' I replied, 'Do you have to rub it in, you twit?' He burst out laughing. Obviously he had been in England for quite some time. He was quite amusing but he gave me this pack of cigarettes and said, 'Go on, keep the packet,' and I said, 'Oh thanks.'

All Germans are not terrible people, they are much the same as us really, but they are fighting for their

side and I am fighting for my side.

When I was in the POW camp, we had a visit from a German General and his entourage. As prisoners we were meant to look dejected. I had a gang with me and told them, 'When he goes by, stick your two fingers up.' As he came I said, 'Ok, ready, turn now!' We had our backs to him and as he came by we turned and raised our two fingers and said, 'Up you mate!' Apparently the German General passing in his car just about had a faint. If you think we were beaten, we were never beaten. People say it was impossible.

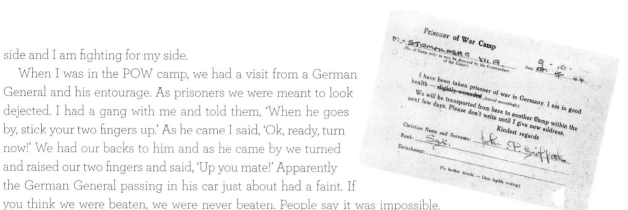

I say that is the way we were, I mean why should you change your ways because you are in a prisoners' camp? Didn't see any reason for me. You would be surprised how awkward you could make it for the guards sometimes, but I must say some of the guards were very good. I got caught making a face at the German General one day and I got fourteen days' solitary. I used to talk to the guard; he was a very nice bloke actually. He said, 'I will teach you a few words in German.' I said, 'Yes, I would like to speak German.' I think he must have been a school teacher the way he taught. He would talk to me outside my door. He would talk first in English and then translate into German. So after two weeks my German was quite handy.

On another occasion we were told to stand to attention facing the road, so I turned my back, with my hands in my pockets, looking over our heads, and got another seven days in solitary but it was warmer in there. It did not worry me at all. That is the way you beat the old Jerry. He never twigged it, his mind goes in one straight line and you cannot bend it. It was a laugh really. Life worked out all right, just the way life is really.

We were down to two men in a bunk, in a three-tier bunk with three bits of wood per bed, one for your head and shoulders, one for your middle and one for your feet, and if you moved wrongly the whole thing collapsed – all night long you would hear the clatter, clatter, clatter – 'Oh you stupid so and so, I told you not to move.' To somebody at home it sounds awful. We had a blanket each, you could see daylight through, they were the same blankets they used in 1914–18 I think, there was no warmth in them. Two men in each bunk. I had a chap called Garmen, and we got on well together. I said one night, 'Can we turn over, gentle now.' We turned exactly together and that was that, you did not move for another hour, you had to do it together or it would collapse. It was ok, you sleep through it. The body adjusts itself to anything

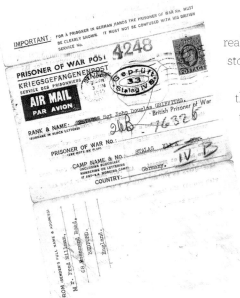

really, starvation anything. I mean we were definitely starved, I was eight stone something when I came back, normally I am eleven.

Every night we went around the perimeter track on the inside and this particular night the Germans heard the bombing of Darmstadt – I think it was the largest city in Eastern Germany, a beautiful city. The Russians wanted it bombed so it was bombed. The Russians moved fast and the German guards became very twitchy and suddenly they were moved out. They left enough to keep the prison camp in order. They had machine guns pointed at us all the time and coils of barbed wire, so there was no way we get out. That night, there were three of us. The two young lads with me had been in Arnhem - Operation Market Garden - which was their first action; I had been in the war from the start. They were good lads but completely lost and one burst out crying. I could have yelled at him but I said, 'It's all right lad, everything is going to be fine.' He said, 'But we can't escape,' and I told him, 'Oh yes we can, you watch, time will come.' It did, this particular night. I always told my lads 'keep yourself fit'. We were on very minute rations - a lump of bread and that was it but you could still keep yourself reasonably fit. I was a fanatic, I suppose.

When we escaped it was so ridiculous. The guards had their families in Dresden and were really worried. Dresden had not previously been touched, it was a really lovely city, full of ancient buildings – the Russians had asked the Allies to bomb it as it was the German's communications centre, so it was vital for the Russians to have it bombed. They got it and of course and it was blown to smithereens. It was like a holy city, it was a beautiful city. The Germans had taken me through the city in a cattle truck going to the prison camp and the buildings were superb. The Russians first bombed the city, then the British and then the Yanks. The British would target railway junctions; if you bust those you bust the railways, they cannot run without power or organisation. The Yanks blasted the hell out of it.

The camp was only 15 miles from Dresden. I saw the opportunity, the guards were in the guard's house. I said to my two fellow prisoners, 'C'mon, let's go, there's no guard on the gate.' We clambered over two lots of wire and we ran like hell. We raced there and got away with it. People asked me how did we escape? Simple – no guards.

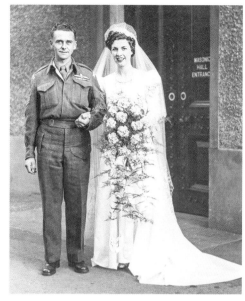

The city was hammered, quite frankly I think Bomber Command just wanted a good target. The war was almost over, we were already meeting up with the Americans and the Russians. I am just an outsider but I never thought bombing a place like that was worth it. All they had to do was blow the communications, they did not have to blast the city to hell and that is what they did. Who was at fault? I do not know. When I escaped and reached the American lines, I asked whose bloody idea was it to blast Dresden off the map. They said, 'Yeah, we all thought that.' The ordinary soldier on the ground could see the fault there. I am supposed to be a fighting soldier but I cannot see any reason why you have to fight to the last man type of attitude. It is stupid. You know when you have beaten him, you know if you have surrounded him, weapons running out, so why blast him to hell? Perhaps I am wrong, but I belong to a fighting unit, I am fighting one man against another – wiping out a city completely through bombing, I see no reason at all.

After the war I flew as a co-pilot on the Berlin Airlift in a Hastings for five months day and night – a beautiful aircraft, brand new.

I then married Jean and we had a son, Alan. I often go back to Normandy and visit the sites to pay my respects and catch up with old friends. I am a regular at the Norfolk Glider Club and fly most Wednesdays. I am getting on in years now, so I go up in a two-seater glider.

Most things in life are not organised, things just turn up and you take the opportunity. People say it must have been terrible as a Prisoner of War, I say no not really. If you think we were beaten, we were never beaten.

LESLIE BEST

My name is Leslie Best. I was born in 1926 and I joined the navy in December 1942, at the age of seventeen.

I initially wanted to join the RAF. Blokes my age back then wanted to be Spitfire pilots but I failed

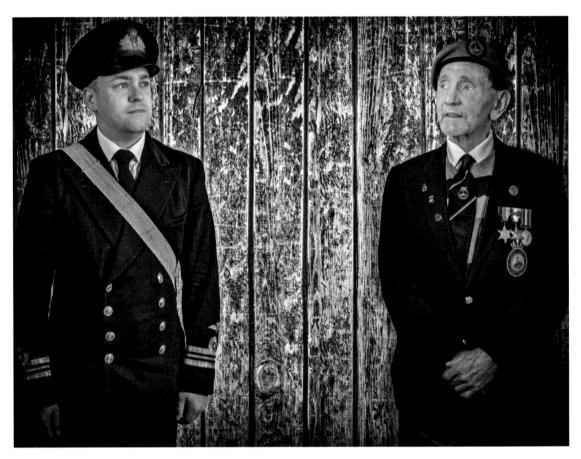

the test because I am colour-blind. So I joined the Royal Navy instead, because if I had not, I would have been conscripted into the coal mines.

I was then shipped out to boot camp but did not stay long, as they had discovered I had been able to read Morse code since the age of twelve and they were short of wireless operators on motor torpedo boats [MTBs]. I had no choice and was sent up to Fort William to learn the codes.

I was posted to Lowestoft for the North Sea and the Dutch coast, and Dover for the English Channel. I was on a short MTB which carried two 21-inch torpedoes with a crew of twelve, including two officers and one wireless operator, which was my job.

We only went to sea at night. We would be given intelligence about German convoys heading south into Rotterdam. We were always very wary of the convoys as they would have destroyers, their purpose was to kill us and their guns were bigger than ours! We would creep in and try not to be seen until the last minute. Our other main task was Z-patrols between the North Sea and Holland to stop any German E-boats getting close to our shores.

I was wounded near the end of the war in 1945 and came out with a 30 per cent disability pension. It happened out at sea, just off the Dutch coast. Our radio stopped working so the skipper ordered me out to have a look. I climbed the mast to fix the aerial and as I climbed down I tripped, fell onto the bridge canopy and landed on the deck.

After the war I married and had two children. While in the navy I had my civilian pay made up. Before I joined the navy, I was in the Post Office as a telegram boy and so I went back to working there.

LEWIS TRINDER

My name is Lewis Trinder, I volunteered on my eighteenth birthday – 13 September 1942 – and joined the Royal Navy.

I had seven weeks' training and was deployed on the Atlantic convoys to protect merchant ships

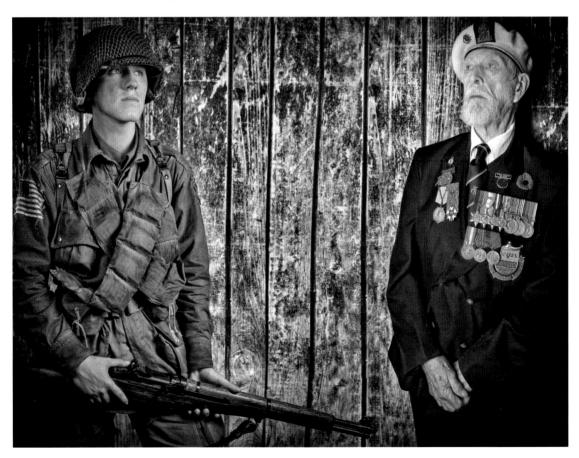

Lewis Trinder, front row, third in from the left

from German submarines. I qualified as a Seaman on HMS *Collingwood*, and then served on HMS *Fleetwood*.

During one patrol in February 1944 we sank six U-boats. This was in my opinion the turning point in the war. The tide had changed and it was all thanks to Bletchley Park, where the Enigma code had been cracked.

I was transferred onto HMS *Magpie* and on 4 June 1944 we sailed out of the Solent, down the western side of the Isle of Wight on the way to Normandy for the D-Day landings. Our ship was reportedly the first British warship to sail into French territorial waters at 2.30 am. We dropped anchor – the reason for this was to be stationary so landing craft could pass safely. The crew at the time thought they were the decoy.

I later travelled to Asia on HMS *Opossum* in 1945, and was demobbed in Hong Kong in September 1946 with the rank of Seaman Petty Officer.

In 1948 I married Vera and we had three sons. I then went into the pub industry and took tenancy of the Castle Inn and then The Princess of Wales pub in Aldershot. Nowadays I travel to many veteran events and have been over to Normandy several times. I am a keen gardener and I can spend six hours in my garden.

GEOFFREY PEDDAR

My name is Geoffrey Peddar and I was born on 18 October 1924. I was called up in 1942 and I joined the Royal Navy. I was sent to Butlins in Skegness for initial training and then went on to torpedo training. My first official position was to make identity discs while waiting for my ship. I served

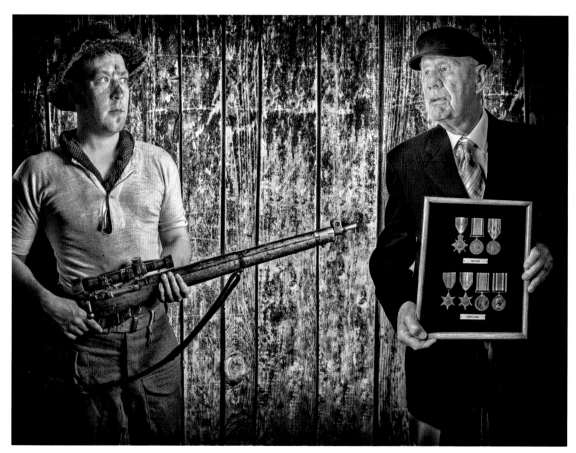

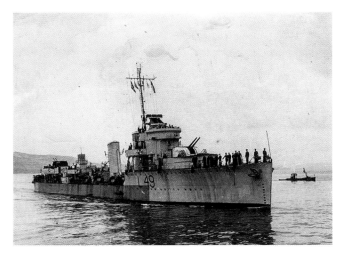

on HMS *Woolston L-49* (pictured left), a Convoy Escort ship from Sheerness to Rosyth in charge of depth charges.

When not protecting the convoy's supplies we would dock in Scotland. If there was a plane that had come down, which happened several times, we just had to carry on because if we stopped I would not be here today. Our ship was part of the fleet that put to sea in July 1942 in an attempt intercept the German battleship *Tirpitz*.

On Saturday 8 May 1945 we were the first ship in to liberate Norway and we were made to feel very welcome by the people of Norway, although the Germans were still around. We saw the German E-boats but they left very sharpish as we arrived. The crew received a thank you scroll from the King of Norway.

One time we went swimming. On the boat there was a door almost at sea level. The funny thing was when we were swimming the porpoises would swim round us as if they were guarding us, which was very reassuring.

I must admit it was a good crowd and we all enjoyed ourselves. When we went to action stations I would be on the bridge near the Skipper, so you had to watch what you were doing. We just sailed along and we did what we were told and, with a bit of luck, we did ok.

After the war I married Sylvia and had two daughters, Janice and Catherine. I then went into the greengrocer business and also had a very successful insurance business. I retired in 1990.

Geoffrey Peddar aged eighteen

GORDON MUSTARD

My name is Gordon Mustard and I was born on 7 July 1926. I joined the Royal Navy on 10 August 1944 at the age of eighteen. I was an electrician on the North Sea Mine Sweeping Fleet.

The boats were not named, as there were so many of them. My boat was the '41'. We operated from

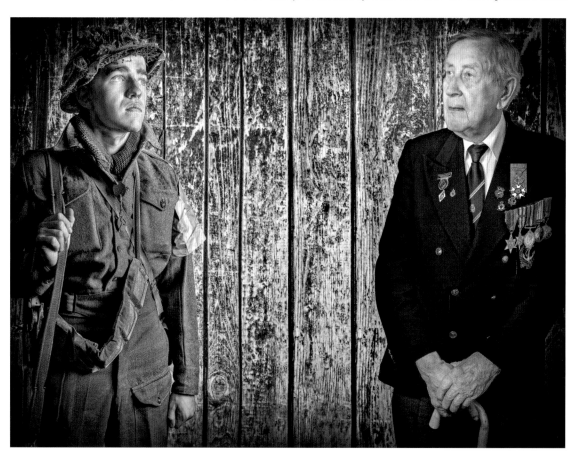

Queenborough Pier in Sheerness, went out in three-week blocks and worked in threes in front of convoys. The German aircraft would drop floating mines, with an anchor attached. We would find the mines by dragging a wire loop cable behind us and would then blow them up using our on-board guns.

My job was to hunt the magnetic mines, which sunk to the seabed. We would pull a twin cable, one of which would have electrodes at each end. We would then pass a current between them, which made a very strong magnetic field. We would drag the magnetic cable near the seabed to get the mines.

There were also mines that were sensitive to the noise of ships' propellers. We used to lower over the side a thing like a bucket with a big diaphragm on it and a hammer would hit the bucket which made more noise than our ship's propeller.

I remember one day we were sweeping right in front of a convoy and for some reason a ship behind us went out of its station and cut across us. We had our three black balls up on our boat which signals 'dangerous waters'. I shouted up to the skipper, 'Have you seen this?' The skipper shouted at them, 'What the devil are you doing?' and all of a sudden their ship blew up. We found out later that a German midget submarine was beside us and they had put two torpedoes into the ship. In our flotilla we had MTBs (Motor Torpedo Boats) and they were equipped with the latest gear that could pick up the exact location of the German submarines very quickly. They sank nine submarines, one after the other that day. They would actually sit on top of the submarine, waiting for it to get the right depth and the right speed, then drop one depth charge over it, accelerate and that was end of it. That was the last time the Germans sent out midget submarines.

I then went and served on an American minesweeper crewed by the British. They were a lot bigger, with a thirty two-man crew and they had everything a destroyer would have. We had to stay in until all mines were cleared.

I left the Royal Navy in 1948.

When you are out at sea, you do not think about death. It is difficult to explain to people who were not there what it is like.

JOHN DENNETT

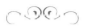

My name is John Dennett and I was born on 23 July 1924. I volunteered for the navy in March 1942 in Bristol at the age of seventeen. I added six months on to my age – I changed the seven to a one. I got in and trained as an anti-aircraft gunner.

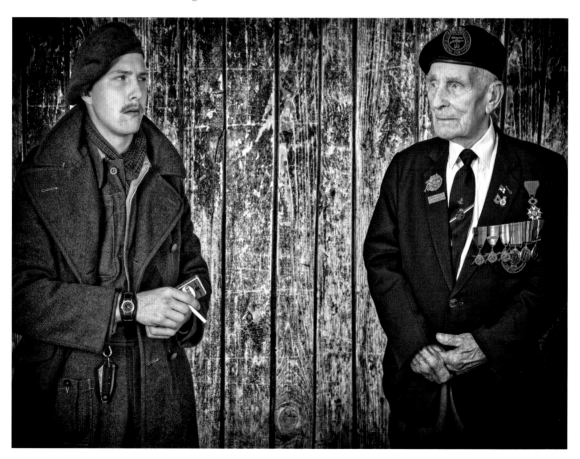

My first active service came in November. I was sent to Scotland and served on RMS *Queen Elizabeth* on Loch Ewe; we then set sail for New York. We spent Christmas 1942 over there in New York and the local families entertained us; they were really good to us. We were at war at home but over there they had only just come in and they really did not know what war was, so they were very good to the sailors. In January 1943 our new ship, LST (Landing Ship, Tank) 322, was put in the water ready for sea trials before setting off with the Americans to North Africa, and we landed in Algiers. We followed Monty's 8th Army up the coast as they advanced and took tanks and lorries up to them to make sure they kept going. When we took Africa, our new assignment was to supply Malta with aviation fuel in jerrycans – we were being used like a tanker for the island. Sicily was our next task in July 1943 and we landed a few times and we again followed the 8th Army as they advanced. By September we reached Salerno, Italy. That was an exciting landing as the Germans were well bedded-in on the surrounding hills; they had the range and were shelling us. It was the luck of the draw that we did not get hit. January 1944 saw the Anzio landings: that was very scary!

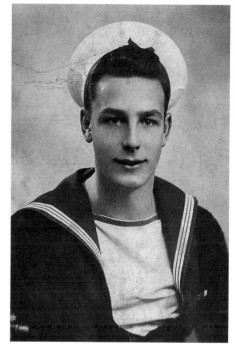

We were then sent home to prepare for the D-Day landings. We docked in Liverpool for repairs and maintenance. By the end of May 1944 we were loaded and ready, waiting for the decision to cross the channel. Ships everywhere, Americans everywhere, British everywhere and the roads around Portsmouth were unbelievable! I cannot understand how Jerry did not realise what was going to happen. When you looked around you could not see the sea for ships – it was unbelievable, I thought nothing could happen to me. When dawn broke on 6 June we were over there. HMS *Warspite* opened up with a heavy bombardment over our heads for an hour and then the troops moved in. Our ship went into Sword Beach at about 10.30 am, once our troops started to move inland. We off-loaded troops and heavy equipment, which included Sherman tanks on the bottom deck and lorries on the top deck. We

had to wait until the tide came in before making a return trip. During this time we were getting dive-bombed and strafe but, once again, it was the luck of the draw; it was an adventure. We made about a dozen trips to the British controlled beaches, bringing back prisoners of war and the wounded to Portsmouth. I did not think D-Day was as bad as some people say. As the volume of equipment we had was colossal, we could not lose. Hitler could not make out how we managed to get so much armour ashore; the LSTs were like a secret weapon.

By August 1944 I had been promoted and took my new position on the aircraft carrier HMS *Patroller*, again on the anti-aircraft guns. It was our job to protect our convoys on the Atlantic crossings. 1945 came around and I was all ready to be shipped to Burma when we were told the war was over. I was due to be demobbed, as I had been in the navy since early 1942. While I was waiting ashore, I was called on to a minesweeper as they were short of a gunner. We were given the job of sweeping our own mines in the English Channel and the Bristol Channel, and I finally came out of the Royal Navy in May 1946.

After the war I went back to my old job with my dad as a brickie in Bath, and I married Joyce in 1947.

When I think back I do not suppose I would do it now, but when you are young it is your duty. In those days you knew you were going to meet some opposition, it is the luck of the draw. The amount of people that got killed was unbelievable and when you think about it, we came home and had seventy-five years of freedom. I say 'we must never forget'. I know the veterans do not, that is why I go back now to visit the sites.

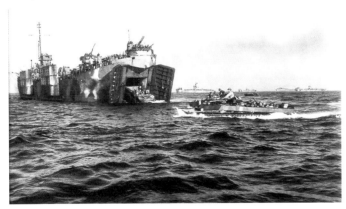

I had a good life in the navy. I must admit I was lucky; I went through quite a lot and came out without a bloody scratch. I cannot understand why they take the good ones and leave the likes of me. It is a funny old world.

I cannot swim, even though I was a sailor – where would you swim to anyway?!

John Dennett's ship LST 322

FRANK DIFFELL

My name is Frank Diffell and I was called up to the navy in 1943, at the age of nineteen.

I served on HMS *Empire Anvil*, a troop ship. My job on D-Day was to control LCAs (Landing Craft Assaults), which ferried US soldiers onto Omaha Beach. I was in the first wave and took thirty-one

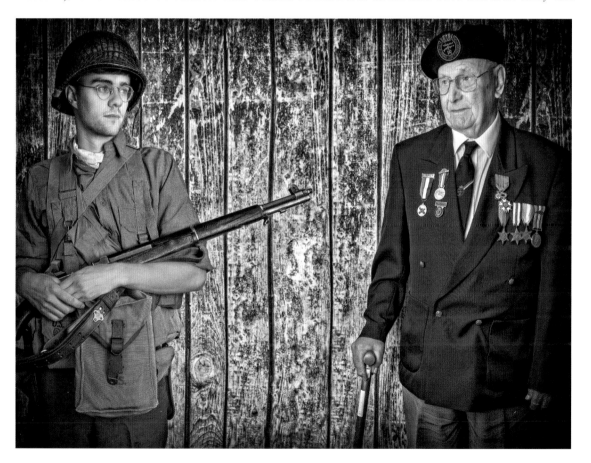

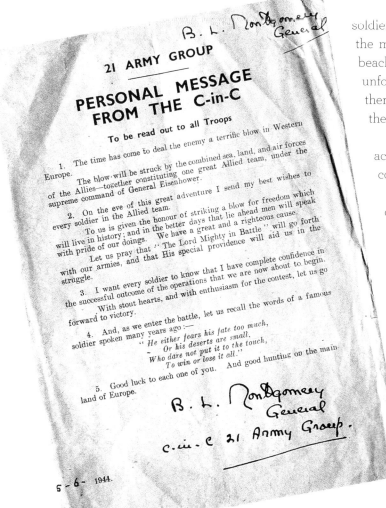

soldiers of the US 1st Infantry Division to the most eastern sector of Omaha. That beach had some of the worst gunfire and unfortunately so many lost their lives there – we were under fire as we landed the troops.

I then continued to take supplies across to the Mulberry harbours, constantly taking fire.

I left the navy in 1946; it was never a career for me. My father had started a transport business, so the rest of my working life I spent driving lorries. I really enjoyed driving all my life.

I married and had two children. I attend many veteran events throughout the country and I also make the trip back to Normandy to pay my respects.

PATRICIA DAVIES

My name is Patricia Davies but during the war I was known as Patricia Owtram. I was born on 19 June 1923, I volunteered for the WRENs (Women's Royal Naval Service) in 1942 and served until 1945 as a Cipher. As I had a specialised job, I started with the rank of Petty Officer WREN and was

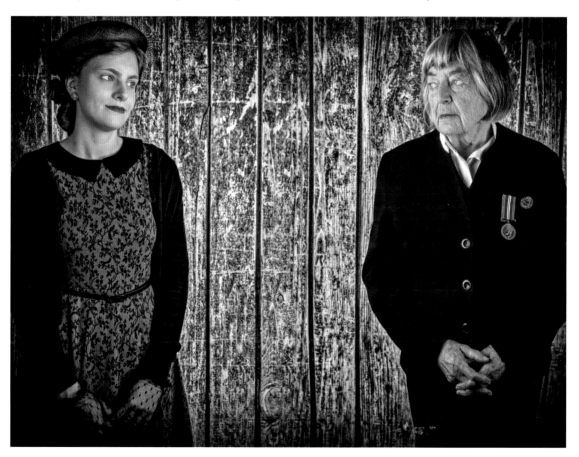

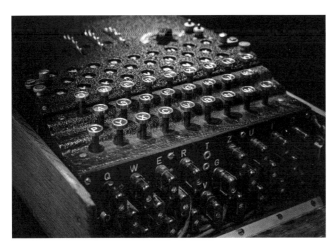

The Enigma Machine

then promoted to Chief Petty Officer WREN.

Because I had learnt German from the family refugee cook who was Austrian, and they needed people as interceptors, I took a German language exam – which was not very difficult – and was trained as a special duties linguist, Y Service WREN (Y being the letter for intelligence). We intercepted German naval radio messages and we were based in little secret stations on the east and south coast of England, which brought us in range of German ships.

My first station was in Yorkshire, where we could listen to ships going in and out of the Baltic, 'Baltic Radio Control Station'. There was not an awful lot of E-boat traffic there, but a little further south the Germans used to send their E-boats and torpedo boats over to attack our convoys that were creeping down the east coast, and to lay mines on the routes of our convoys if they could get in. If we could pick up their signals we could tell the nearest naval base and they would send out a destroyer or torpedo boat to intercept them.

The main part of our work was for Bletchley Park – the decoding centre – because a great number of messages were in naval Enigma code. We would write the message as accurately as we possibly could by listening to the radio signals on our headphones. We then sent these messages by teleprinter, which at that time was the fastest way you could communicate to Bletchley Park, and it was very much one-way traffic. We took down the messages, sent them to Bletchley, but we never of course – because it was so secret – heard what they were actually about. We never knew that bit or whether indeed they had decoded them.

When I volunteered for the WRENs I had no idea there was a branch that listened to German radio. When I passed the German test I was very worried I was going to be a spy and would have to jump out of an airplane, which was the last thing I wanted to do. Bletchley Park is an amazing story because it

was top secret and word never got out, despite thousands of people working there.

There was a brief time when I was sent to a secret station under Scarborough racecourse where they tried to get bearings on German U-boats. The U-boats hardly ever spoke for obvious reasons but when they did surface and sent a message, everybody in this big underground hanger had to hold their breath while stations down the coast – which did direction finding – tried to get a fix on the U-boat because they were creating havoc on our convoys in the Atlantic. It was a secret, rather sombre place and I was quite glad to get back to listening to ships we covered in the Baltic.

Then from Yorkshire I went down to Lyme Regis where we covered the west end of the channel. We had taken over the golf course on top of a cliff and we could actually hear the German lighthouse keepers who had been put in to replace the French ones on the Normandy coast. They would sometimes say things to each other like 'if you look out in an hour you will see something interesting' or 'you must set your lights at eight o'clock', and this would give us information that there was going to be a convoy and then we could let the naval base know and they could do something about it.

At Dover, my final station, if we got a signal at 110 degrees that was Calais harbour and that would be a ship going in or coming out of Calais. Dover was the most exciting of my three stations because we were only 22 miles from France, we were getting a lot of traffic from coastal defences with torpedo boats coming out of the harbours of Boulogne and Calais. The Germans would use their long-range guns to shell British convoys going past under our cliff. It was a very lively place indeed and very interesting being there for D-Day. We saw all the bits for the Mulberry harbour and landing craft going past in convoys under our cliff. We had to misinform the Germans, making them think we were going to land in Calais rather than Normandy. I even saw Churchill and Monty on one occasion when they came down to look across at the French coast from Dover, and they obviously hoped they would be seen.

When the German Fleet capitulated, I went up to Admiralty in London as a translator and then to General Eisenhower's London intelligence headquarters, which was on the top floor of Peter Robinson's

shop. We went in the back door so no one would notice, or so it was hoped: large numbers of American Army, British Army and Navy, and people who knew German and went through documents that had been captured at various German administrative headquarters to find out who were war criminals and ought to be brought to trial at Nuremburg.

The war seemed to go on and on and on because you did not know when it would end or how it would end, and in a way we did not have our late teenage years because many people went straight from school into the kind of job which was far more responsible than you would ever normally have had at eighteen. We were very conscious in our branch of the responsibility of our listening job that we must get an absolutely accurate record. We felt quite privileged to be contributing to the defence of the country.

We were aware that our families were having a much harder time than we were, with our rather good rations and our interesting work, and with people our own age and with similar interests. There was lots of entertainment and facilities that were provided if you were in the forces that you did not get as a civilian, so there were a certain amount of pluses although it was a very dark time and went on for years. It was not altogether a disadvantageous way of growing up.

My father was a prisoner of war in the Far East and my mother heard nothing from him for months. We did not know if he would survive or get back, so when we celebrated VE day it was a great celebration but an awful lot of families like ours wanted VJ day. Luckily, my father did return home and lived a long and happy life.

My sister Jean joined the First Aid Yeomanry and was trained as a Cipher Officer for the army, and she went to Cairo and then Italy. Like me, she signed the Official Secrets Act. Neither of us told each other what we did for thirty years after the war.

RUTH JOYCE GILBERT

My name is Ruth Joyce Gilbert and I was born on 24 February 1919. I lived in Kew, west London during the war – as I still do – with my family. However, my aunt had a place in Eastbourne on the south coast of England, so we went down there quite often for a visit to get away from the Blitz in London.

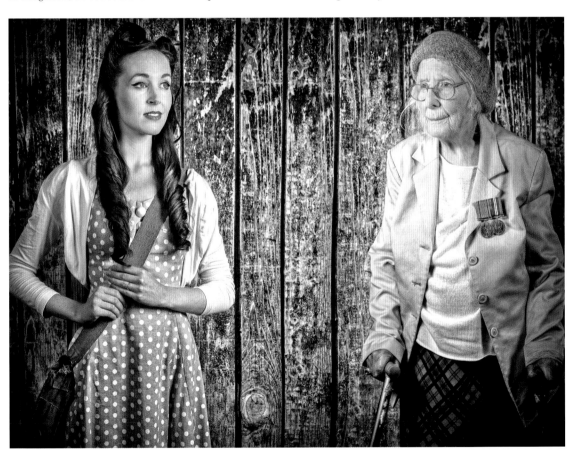

Ruth Joyce Gilbert, far right

I remember on one occasion coming home from Richmond on the bus, when I looked up and saw a dog fight over Richmond Park. I could hear the 'pop, pop, pop, pop, pop', guns firing everywhere! The bus suddenly stopped and the driver shouted, 'That's it for me, I'm not going any further, you will have to make your own way home.' So I ran from the bus and lay down on the ground. When I got up once it had quietened down, my long satin cloak was filthy! It was a long walk back home to Kew. Whenever there was an air raid we did not bother going down into the shelter, we were much too brave!

My sister had joined up and I thought I better not be left behind, so I joined the WRNS up in Liverpool. I came back to London and was told Commander Stuart Lockhart was interested in me, as he thought I was officer material and wanted me to go to Greenwich to work at the Royal Naval College. I, of course, agreed and became a Commissioned Officer in the WRNS, which stood for Women's Royal Naval Service, commonly known as the WRENs.

I worked in Chiswick, which was the main hub for communications between Churchill, the navy, army and RAF. All the telephones were manned and I sat in all the negotiations because they had to have representatives from the three forces plus civilians. My boss told me 'if that red telephone rings, pick it up and answer it because it will be Churchill at the end of the phone'. The phone did ring and it was my job to make sure it was transferred to all the forces that were connected with all the gunnery stations dotted around London.

The end of the war felt rather sober in a way for me, but I did go to St Anne's church on Kew Green to celebrate D-Day. The Upper Gallery is normally closed, but I managed to take a seat up there as it opened for that special occasion. I eventually got a job working for Shell. I never married; I have always been a single lady.

EDNA GULLIS

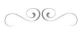

My name is Edna Gullis. My mother died when I was three and so my paternal grandparents took me in. They lived on a farm, which is now Heathrow Airport in west London.

One night during an air raid, a bomb hit the side of our shelter and pierced 30 ft down into the

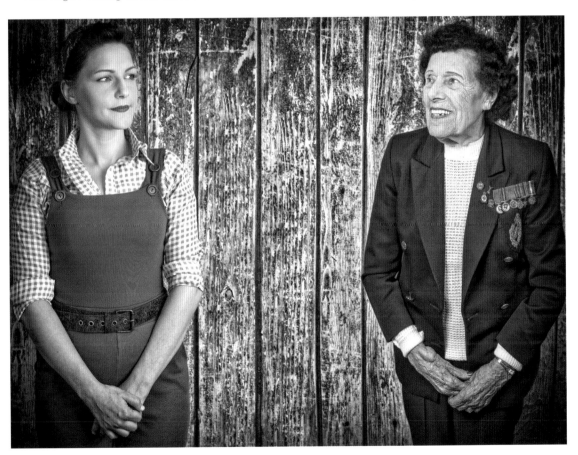

ground. The bomb did not explode but unfortunately it buried us in the shelter. The demolition squad dug me out. I was the only person that came out alive – I was only sixteen years old. We had heavy bombing in London every night; I lost so many friends, I did not care if I lived or died!

I joined the WAAF (Women's Auxiliary Air Force), working on the telephone switchboards when I reached eighteen, in Acton, London. I was then stationed at RAF Innsworth, Gloucester, after which I moved to Morecombe Bay to work along side Sarah Churchill, Winston Churchill's daughter. I was then stationed at Uxbridge, where General Eisenhower had an office – so I met two very interesting people!

In 1941 I met Allan (my future husband) but I did not fancy him – he was a boozer. I said I would go to the pictures with him but not on my own! During the film there was an air raid, so we all had to come out. Allan's father was outside, he was an Air Raid Warden and said, 'You take that young lady in the house'; it was a really bad raid. Allan's mother was such a lovely lady and told me she liked the wings on my WAAF uniform, which I always remember to this day. She asked me to come and visit her every day, as she was ill, she had cancer. So I visited her every day. I was frightened but I never showed it. Sadly, she then died and Allan became ill and went into hospital. He got better and as he left hospital he got his papers, he was called up – and I think it made a man of him! Allan got bigger and stronger; it really did him good. 1944 came and we got married and he went to France. I wanted to go too, but because we were married I needed his consent and he would not give it – crafty devil.

Allan came home in 1945 after the war, and we stayed with his father for two years, then luckily we moved out into a small cottage. We had our daughter in 1946, followed by two sons and I enjoyed looking after our home and raising our children with Allan.

VIOLET MARLEY

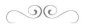

My name is Violet (Teddy) Marley and I was born in 1925. I was able to choose between the Women's Land Army, the Auxiliary Territorial Service and the Women's Auxiliary Air Force. I chose the WAAF because all my friends joined the WAAF.

We were bombed heavily in the Croydon area but, luckily for us, we were only hit by small bombs. One night an incendiary bomb landed through our roof. We were fine and we received lots of clothes from our friends. About one in fifty houses in the Thornton Heath/Croydon area were bombed. I used to stand on the steps of our front door in Thornton Heath and watch the dogfights. The sky over Croydon was full of fighter planes. We thought it was rather exciting; we did not really know what was happening. Looking back we were young and did not know any better.

It was while stationed at Brize Norton that I was given the nickname of 'Teddy'. All the WAAF girls slept in married quarters and a girl called Tilley Cortier, who had five brothers, felt lonely, so she would get in my bunk and cuddle up with me, and she would tell me I was like a teddy bear. I have been called Teddy ever since. I do not know if I am so cuddly now though. Brize Norton was a RAF Heavy Glider Conversion Unit. I was on general duties, working in the Met Office and as a Wireless Operator in Cramwell. I was then posted to RAF Sculthorpe in Norfolk, which had one American airplane! We used to sit in the watchtower all day doing nothing apart from reading books and doing crosswords. The plane only went up about once a month! I was very disappointed; I still am. The most exciting thing I did there was guide in some Canadian planes, as they were in trouble. They landed safely.

I married during the war and left the WAAF in 1944 to give birth to my daughter. I then went back to work after the war in the Employment Bureau. I then married again and went into business with my husband who had two motorcycle shops in Croydon but both were unfortunately burnt down in 2011 during the Croydon riots.

I just recently had a heart pacemaker fitted, but I have been told I am tough as old boots!

CHRISTINE WOLLEN

My name is Christine Wollen, I was born in 1924 and I was a nurse in the war.

I was fifteen when war was declared. I remember sitting my exams in the basement of my school because the air raid sirens could sound at any moment and we could not be moved during the exams.

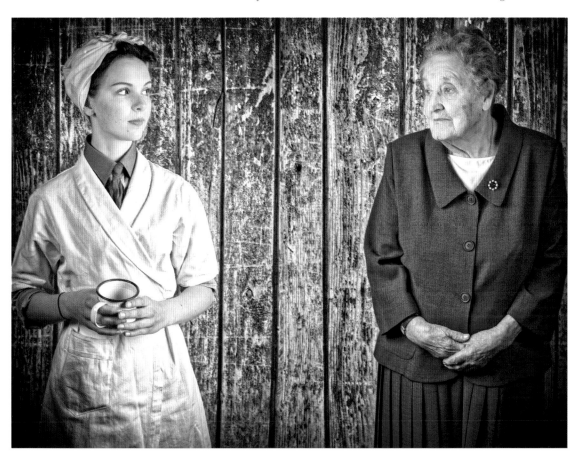

The first excitement of the war for us was when a German parachutist landed on our school netball court.

I remember the first Sunday after war was declared. I was with my Aunt Winifred at my grandparent's house. They were very strict Baptists and Sundays were spent Bible-reading, playing your instruments or going for a walk. My aunt picked up her knitting, and I can hear my grandfather's voice now, telling her, 'Winifred, it's the Sabbath', and I remember her replying, 'Father, there's a war on.' My aunt was knitting balaclavas for the soldiers.

We were bombed quite frequently in Bristol and the local timber yard would often get lit up. I remember seeing the flames; they were nearly as high as our house. I sneaked up for a closer look and I could see the shadow of the bombs dropping through the flames. I often found it very difficult to walk home; there was so much destruction. Walking around bomb craters, where there used to be a road, my mother that day was delighted to see me home. On one occasion an incendiary bomb hit our garage at the bottom of our driveway and we lost our car; that was quite a blaze!

As I was coming home from school one day on my bicycle, I heard the noise of a plane. The Germans thought they had found a way around the Barrage Balloon. I stood there with one leg over my bike seat looking up to see a German tail gunner shooting everywhere. He went down our drive; you could see holes up and down our driveway. One of the bullets went through my school skirt, so my mother had to make another skirt out of my father's pair of trousers! That plane did not get out of our Barrage Balloon; it was caught further down and crashed. The wind had caught one of the balloons and blew the cable over into the direction of the German plane.

I remember going out for a walk with one of my school friends and we sat on a bench. We had a great view of Avonmouth and Bristol Docks. Suddenly we saw this man coming over, and he sat beside us. He asked us if we were local but we told him no, he then asked us about the comings and goings of ships in the harbour but we told him nothing. As we left, we told a policeman who we saw on the path back. A few days later the police came to our school and asked to see the two girls who were on the bench and who had spoken with a man. The police told the whole school that we had actually met a German spy! We were rather excited and really thought we had done our bit for Britain – loose lips sink ships.

My cousin came home on leave from the RAF and asked what I was doing. I told him, 'I am now studying for my Higher exams.' He quickly stated, 'There is a war on.' I said, 'Well what can I do, I am only sixteen?' and he responded, 'You could nurse.' I went home and told my mother I was leaving school and I went nursing.

I went to a children's hospital because I was not old enough to work at a general hospital. When I was eighteen I moved to a general hospital, the Bristol Royal Infirmary. We accepted the troop ships that came into Avonmouth and changed all the soldiers' dressings before they went on to a military hospital. It was here that we learnt how good maggots are at cleaning wounds. The Americans had antibiotics but we did not. They used to treat their very badly burned patients at our hospital. The American side of the ward would receive antibiotics and our side of the ward would not. Our patients would ask us why the other side of the ward was getting better and they were not. There was nothing we could do about it and it was really distressing.

My grandfather died literally as the bells started to ring. It was the end of the war. I remember my aunt saying, 'They are ringing father up to heaven.' We had just lost our dear grandfather but we were all dancing around the house, celebrating and having a drink; it was a grand night, it was really wonderful.

We did not know how dangerous war was; we had no idea. It is an extraordinary thing to say but there was not so much fear as excitement. We knew you had to live through it and at times it was quite exciting.

We had to do something about it, we just could not let Hitler take over other countries and dominate them. I thought we should have gone to war but I do not think any of us thought it was going to last as long as it did. It was quite a long war, wasn't it?

After the war I trained as a midwife and went to London to do District Midwifery. I then got married and moved to Richmond, west London to work in the Richmond Royal Hospital in the theatre until I had my two girls. I went back to work as a District Nurse and when I reached the age of seventy, I was told they could no longer insure me. After some time I was asked to come back as a medical researcher and then on to transferring patients' files to computer. I retired at the ripe old age of ninety and that is my story.

ANITA HOLMES

My name is Anita Holmes and I was born on 6 May 1941.

My arrival proved to be a traumatic event for my father, who could handle the rigours of war but was all at sea when it came to 'things that ladies did' to keep the human species from dying out.

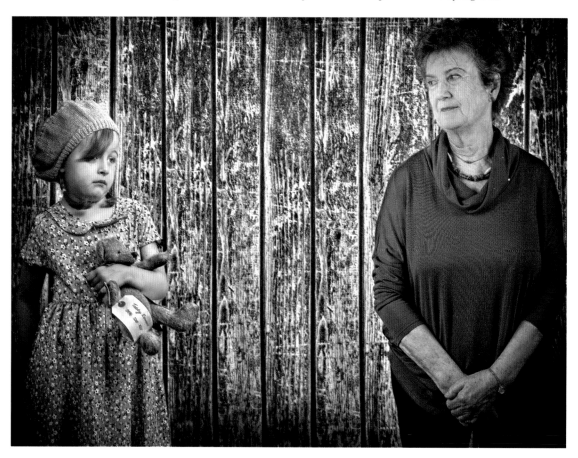

Our evacuation consisted of a rented bungalow in the grounds of a poultry farm near Tonbridge, Kent. In the village of Five Oak Green everybody was busy with survival, growing vegetables in the formal flowerbeds. The hedgerows were full of primroses in the early spring and wild roses in the summer.

I spent my early years in the village living with my mother, her sister Joan and my cousin Yvonne while our respective fathers were away at war. Keith Roberts, Joan's husband, was stationed in India for most of the war, while my father was a Major in the 21st Army Group. My father Laurie was called up in August 1939 just before the war started, joined the Royal Engineers and was sent to France with the British Expeditionary Force. By then my father was a Lance Corporal and was one of the last to retreat from Dunkirk, blowing bridges as they went. On one occasion he was blown into the water by one of his own explosives! During a brief leave in England after Dunkirk, my father married my mother, Dora Myring, in June 1940. During the allied invasion in 1944 my father was occupied with strategic bridge control at Caen in Normandy. Towards the end of the war, by now a Major, he worked in the London offices of General Montgomery's staff. His final task was to rebuild bridges in Holland before being demobbed in 1945.

By contrast, my mother's wartime anecdotes were about rationing, black-outs and the challenge of making-do. She was a strong young woman with an aptitude for cooking and sewing, and would have made a capable woman soldier or land girl if she had not, as she put it, added to the war effort by marrying a soldier and giving birth.

My aunt and my mother spent the long evenings knitting or cutting up old clothes to make new ones for us and for themselves, as well as making dolls' clothes and dressing up clothes for us to play with. My favourite toy was a wooden butterfly on wheels with a long stick that flapped its wings when pushed. A German prisoner of war who had lived at the farm had made this for me. He was a good-natured man named Walter, and although his temporary home, a tiny room at the end of the chicken shed, was full of noise and smell, he considered himself fortunate to be away from the fighting and not in a prison camp. There was a shortage of toys, and my mother made dolls out of pipe cleaners that Selfridges would buy from her to sell at Christmas time. We

had one of these dolls on top of our Christmas tree for many years after the war ended.

As we grew up, my cousin Yvonne and I were blissfully unaware of the devastation of our towns and the deprivations of the British people. We never saw the doodlebugs that passed overhead from time to time, nor did we know that our bungalow suffered a hit by shrapnel one night while we slept, passing from one side to the other, knocking down a deer's head and antlers from the wall on its way through!

Peace inevitably brought change to our household. Joan and Yvonne went to live in Luton, where Keith (my uncle) set up his architectural practice. My father, who was in the same profession, chose London to set up. There was plenty of work for the building trade after the war, repairing and replacing bombed buildings and erecting schools for the new generation. Both men became successful architects.

My mother stayed at home to look after me, and my brother and sister who were born in 1949 and 1953. She had always wanted her own garden and became a self-taught expert. She also learned to be an excellent cook and dressmaker, skills that she passed on to my sister and me.

I left school and went on to college to do a crash course in secretarial studies. I was interested in fashion and journalism and went to work for Condé Nast Publications as a secretary for Vogue fashion editor, Lady Clare Rendlesham.

I met Paul and we married in 1964 and had three children. I stopped work and spent the next five years painting and decorating our newly bought 1930s house. Paul had a very successful career in banking. We are both retired now and enjoy life in a semi-rural village, gardening and having our children and seven grandchildren over to visit.

I found out about World War II gradually as I grew old enough to understand something of the years of destruction, worry and deprivation it had caused. Although they were mainly concerned with building a new life for themselves and their families, the adults would talk about 'during the war' from time to time, so that it became a familiar experience to listen to their reminiscences. I remember that the Holocaust in particular was never discussed and how incredulous and horrified I was when I first learned of it from a television programme. My parents were reluctant to talk about it, as though they had buried the worst memories long ago and wished neither to remember nor burden their children with the subject.

My lovely mum managed to write one page of her memoirs before passing away at the age of eighty. My father died in 1989, leaving several campaign medals and photographs of his part in World War II. He never lost his liking for the unique camaraderie of men who had shared his wartime experiences. I miss them both dearly.

DOROTHY HAYMAN

My name is Dorothy Hayman and I was born in 1928. When I was eleven I remember being told that war had broken out. It did not mean much to me to be honest; war was something that had happened years ago.

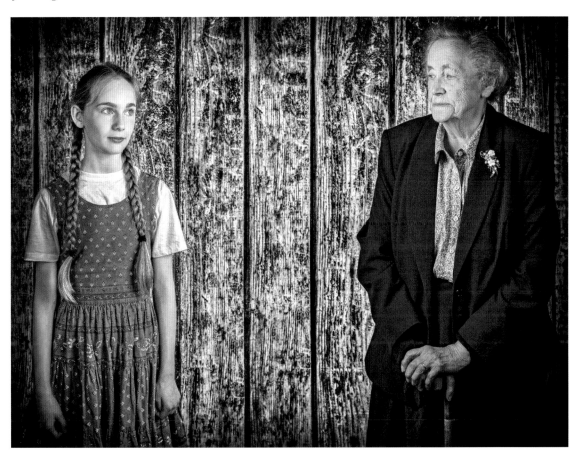

I went to school in Datchet, a small village near Windsor, then on to west London and then to north-west London; my mother was a nanny so we moved quite a lot during the war. I also became a nanny during the war, after I had left school at the age of fourteen.

I remember one Friday my mother and I decided to walk into Windsor from Datchet to get some fish and chips. As we walked along the road, we saw this lone plane approaching. I looked up and saw the plane shooting at us, so mother and I finished off in the ditch. We never did get our fish and chips. Every time I have fish and chips now, I always remember that day. It was a scary time.

I heard about D-Day on the radio. We counted the American planes out, and in the evening you could count them back again. We would often think about what had happened to the two or three missing planes.

We got our news from the radio and, of course, the cinema. We would go to the cinema to see the Pathé news because they did not tell us much in the newspapers. We would go to see one film and the rest was all news. I used to go after cookery class.

When we heard the war was over, I was allowed the day off to go to Trafalgar Square to celebrate in London.

I knew a boy called Peter, as his mother used to babysit the children that my mother used to look after when she had time off as the nanny. Peter was older than me and he joined the Irish Guards and went to North Africa, Sicily and Italy. I used to make him toffee and put them in an old treacle tin, and I would also send him letters. He told me afterwards he received all my letters but never the toffee. I married Peter in 1950 and we are still together after all these years, with one son and twin daughters.

PAUL HOLMES

My name is Paul Holmes and I was born during the Battle of Britain, on 14 September 1940.

It was unsafe to stay in London, so my mother gave birth to me in a hospital in Epping, Essex. Shortly afterwards a German bomb descended by parachute and was found hanging from a tree in

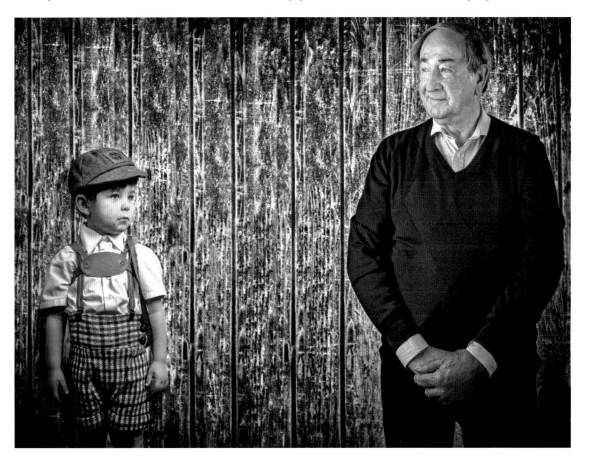

the grounds. We were hastily transferred by ambulance to a different hospital, and after my mother had recovered we went to Devon to meet up with my three brothers who had been evacuated and were living at Horsehill Farm, Ashburton. My mother, four-year-old sister and I were allocated a small cottage in a field belonging to the local postmaster and his wife who lived in the town. It must have seemed very quiet to my mother, who until then had lived in the East End of London, but she always held fond memories of the countryside and the kindness of the local people who took us in. I was given a chest drawer to sleep in because there was no cot available. As a small child I was unaware of the fighting, bombing and food shortages, as my mother never showed her children the anxiety she must have been feeling.

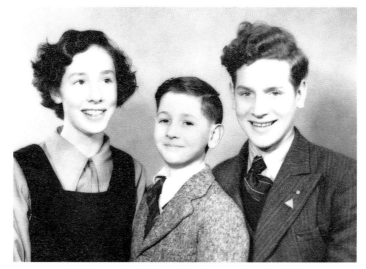

Paul (centre) with sister Kathleen and brother Bob

We stayed in Ashburton for about three years, while my father served in the Military Police stationed in Croydon. Before the war he had worked in Billingsgate Market, and in Croydon he saw an opportunity to use his expertise to open a shop selling fresh fish once he was demobbed. Fish was not rationed and was a popular choice for mealtimes, which meant that the business was successful, and this led to two other shops being opened in Addiscombe and also one in Billingsgate.

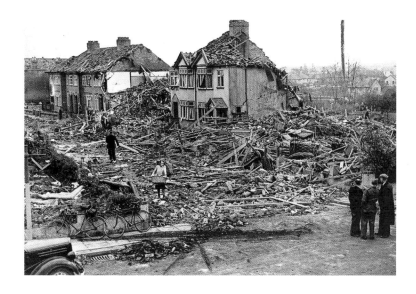

When it was safe to return, my family moved from Ashburton to a house in Addiscombe, where a row of houses opposite had been bombed. Bombsites were a dubious playground for town children for several years after the war ended, with few precautionary measures taken to keep them out. Toys were in short supply – I can remember being upset when my toy car disappeared into a tank of water. Our parents were kept busy with the shops and rarely had the time or inclination to reminisce. My distant memories of home life are of noisy brothers and large family meals. My mother made sure we never went hungry – she became an expert at cooking fish and chips, which is still my favourite.

After the return of peace in 1945, my older siblings were sent to local schools while I attended Miss Peachy's nursery and began my lifelong obsession with reading and collecting books. I left school and got a job at a private bank in Mayfair, London. I married Anita in 1964 and in 1966 we bought our first house for £5,000. We had three children. I eventually set up Lloyds Private Banking and became Chief Manager in 1986. I retired in 1993 and my wife and I set up a financial consultancy together and after twenty years we decided to retire in 2013 and enjoy life in a semi-rural village where our main occupation is gardening and having our children and seven grandchildren to visit.

TONY VINCE

My name is Tony Vince, I was born in December 1939 and I lived with Mum and Dad, my brother and sister in Wandsworth, west London during World War II.

To us children in those days, it was wonderfully exciting. I remember our Anderson shelter arriving

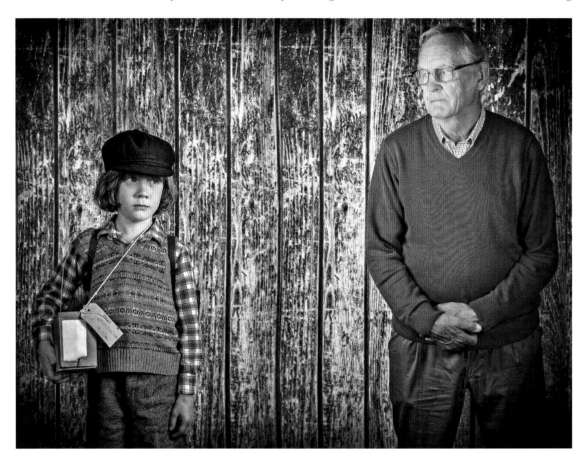

at the house and being installed in the back garden. A huge hole was dug and the corrugated sheets were put in place. I also remember the Morrison shelters, which were metal cages, and installed under the living room table. In the event of an air raid you either hot-footed it to the shelter or hot-footed it under the table. When the siren went, I would get out of bed, if I had time I would put on a rain jacket, go downstairs, put on my Wellington boots and head down the garden path to this wonderful but very small shelter. In the shelter were two beds and some candles, and the door was shut behind us. We spent the night there and it was so exciting, I cannot describe how wonderful that was. There were bombers flying above trying to kill us but it did not occur to us, we did not know what

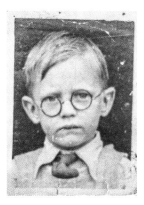

it meant at that age. People used to run for their lives and were horrified by the noise of the siren; I loved that sound.

I remember the first time I was asked to put on a gas mask in my primary school, there was a feeling of claustrophobia, the smell of rubber and the urgent need to get it off again quickly! I did better the next time when a friend put his on, and demonstrated that, if you breathed out heavily, you could make the sound of breaking wind through the sides of the mask. Of course I wanted to try it, and did! I also remember a mask designed to look like Mickey Mouse, which was fun to wear.

My father was in the Home Guard and was also the local fire warden. One morning I remember him knocking on the shelter door saying, 'Quick, come out boys.' 'Why, what's the matter dad?' we asked, and he said, 'Look up in the sky.' We looked up and we saw this strange craft flying across the sky with an even stranger drone – it was a doodlebug, the V1 flying bomb.

It puzzles me, the fact that I can remember the Blitz at the age of eighteen months old. As I sit here, I can actually hear bombs dropping now, and the drone of airplanes flying above the house heading for London and in our area, Wandsworth Gas Works.

After an air raid I could not wait to go up to Wandsworth Common with my family and friends, looking for bits of bomb casings, commonly know as shrapnel. We used our shrapnel as currency, swopping them for comics and sweets. I remember we found a car on a bombsite, at least part of one. It did not have any wheels and it was a sports car, a tank, anything we wanted it to be. We were always looking for bits of bikes. If you wanted a bike in those days, you did not buy one, you made one. I

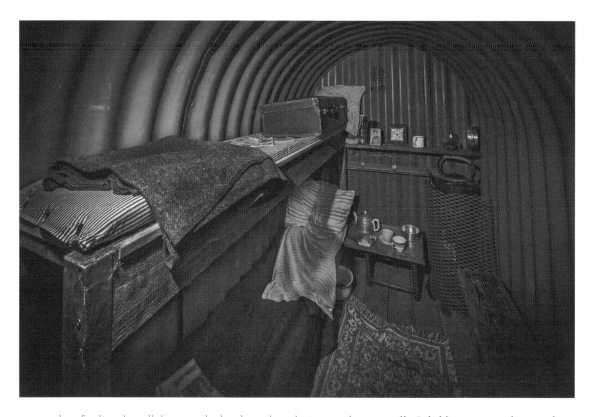

remember finding handlebars and wheels on bombsites and eventually I did have enough to make a bike. I painted the wheels silver and it looked like new.

Our parents always told us when we went out to play not to go near the bombed-out houses. Of course we played in all the bombed-out houses. It is what kids did; it was so exciting to explore and see what we could find. One of ours friends had actually fallen through a floor, ended up in the cellar and was rushed to hospital.

After the war my father still had relics lying around from when he was in the Home Guard. My brother and I used to play with this toy in the garden, it was a hand grenade – of course it was a dummy one, used for practice!

To me, VE Day and VJ Day meant street parties. I have seen many photographs of all our street parties but noticed there were no men in them. It was only until recently that I discovered they would have been still overseas and not yet demobbed.

London needed to be rebuilt. There was a big influx of Irish workers and the government needed places for them to be housed. My mum and dad decided to help the war effort and took some of them in. I thought it was a bit odd to have complete strangers living in our house, but I have have to say they were the most wonderful chaps, wonderful men and so strong.

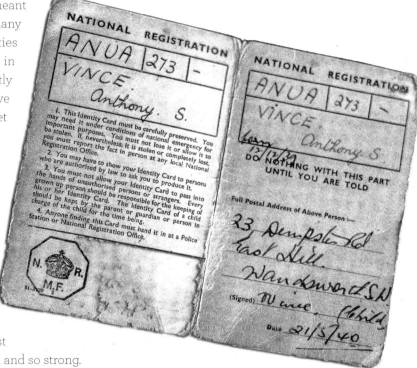

Life rolled on, and I started work as an office boy in Wandsworth at the age of sixteen. I married Margaret who I met for the first time at the age of ten. Children did not happen for us but we have thirty godchildren! I eventually retired at the age of sixty-seven.

I look back with fond memories at a childhood of lovely family life. The war was a time of adventure and excitement as a child.

I remember when I was ten going into an army surplus store with my friends and buying red flags bearing a large white spot. We tucked these into our collars and raced around like Superman. I realised many years later that they were Japanese flags and wondered if people were horrified to see this spectacle! Kids eh?

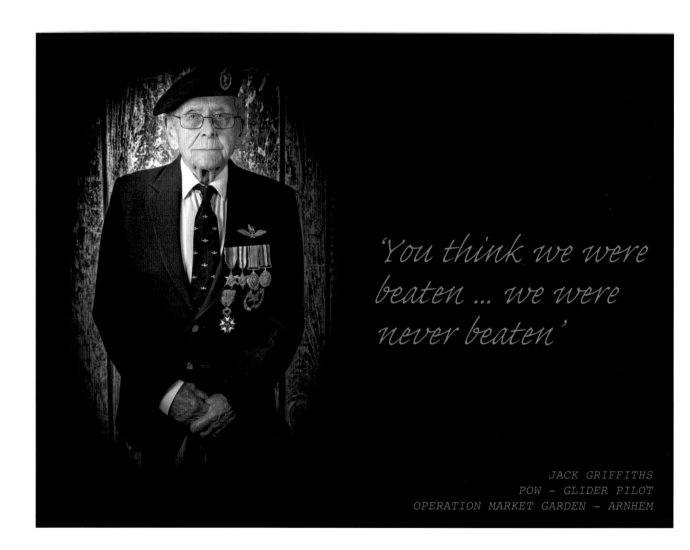

'You think we were beaten ... we were never beaten'

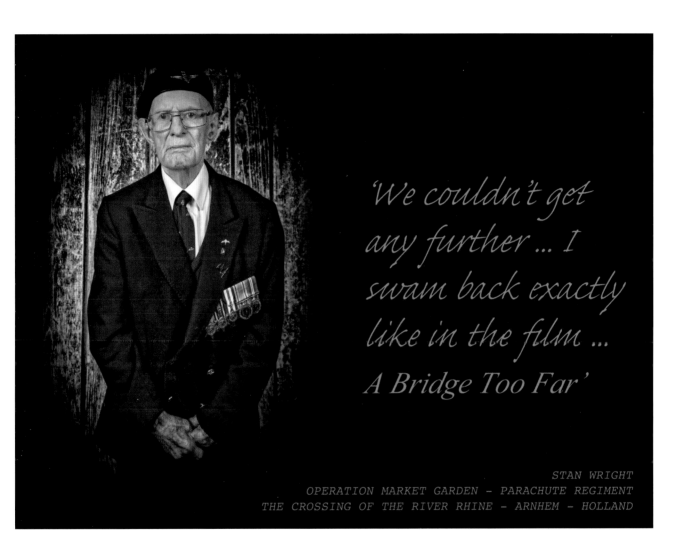

'We couldn't get
any further ... I
swam back exactly
like in the film ...
A Bridge Too Far'

STAN WRIGHT
OPERATION MARKET GARDEN - PARACHUTE REGIMENT
THE CROSSING OF THE RIVER RHINE - ARNHEM - HOLLAND

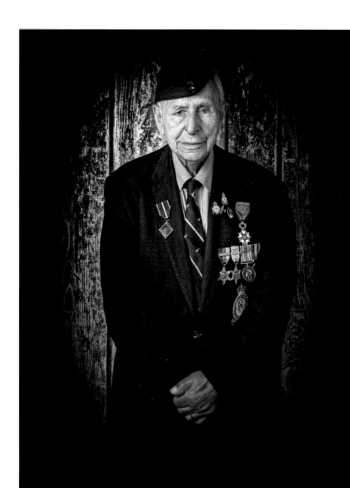

'The less we knew
about each other ...
the safer it was for
all of us'

WILLIAM TAIT MOORE
SOE AGENT AND SUPPLY AIR DROPS
LANCASTER BOMBER – FRANCE – HOLLAND

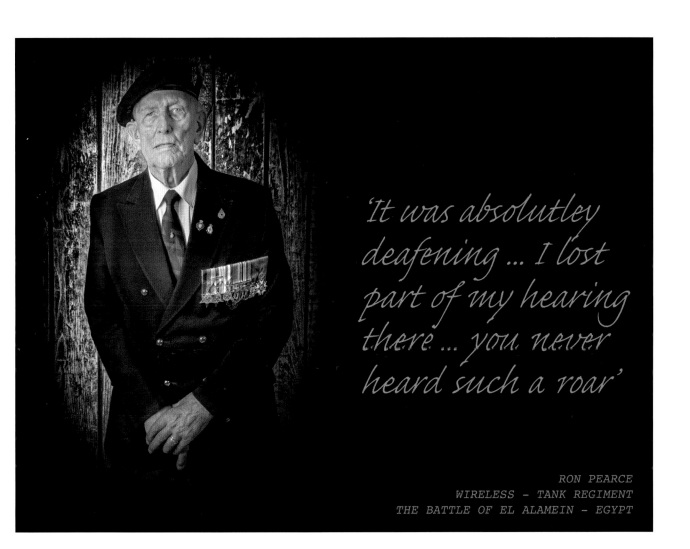

'It was absolutley deafening ... I lost part of my hearing there ... you never heard such a roar'

RON PEARCE
WIRELESS - TANK REGIMENT
THE BATTLE OF EL ALAMEIN - EGYPT

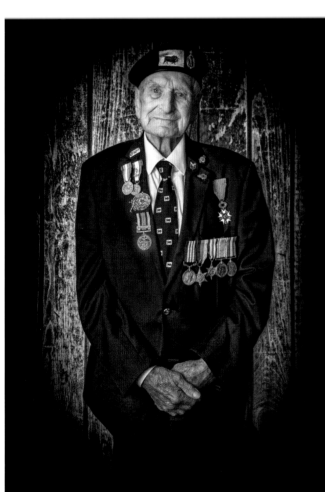

'We liberated the Belsen camp ... but I really don't want to talk about it'

BILL PENDELL
SCOUT CAR - 11TH ARMOURED DIVISION
BELSEN CONCENTRATION CAMP - GERMANY

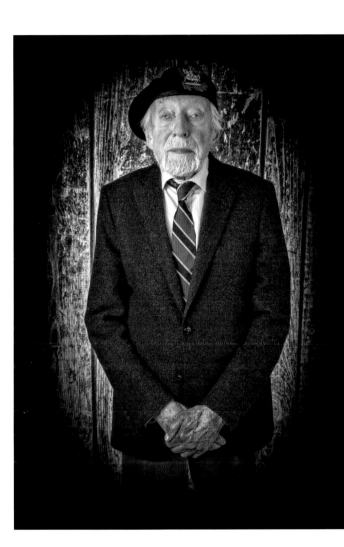

'There hasn't been a war since that was justified ... that's why I don't wear my medals'

RON COX
WIRELESS – 11TH ARMOURED DIVISION
OPERATION GOODWOOD – CAEN – NORMANDY

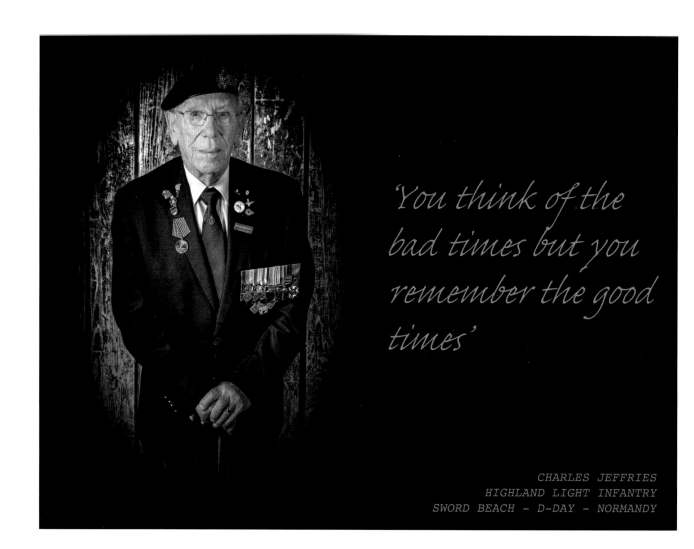

'You think of the bad times but you remember the good times'

CHARLES JEFFRIES
HIGHLAND LIGHT INFANTRY
SWORD BEACH - D-DAY - NORMANDY

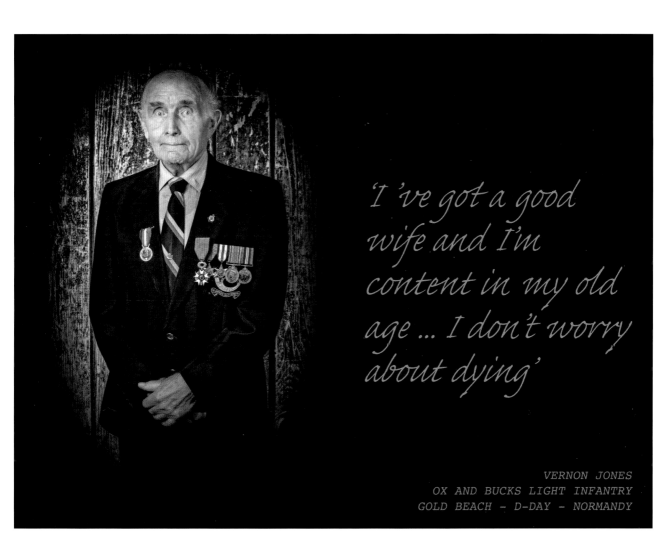

'I 've got a good wife and I'm content in my old age ... I don't worry about dying'

VERNON JONES
OX AND BUCKS LIGHT INFANTRY
GOLD BEACH - D-DAY - NORMANDY

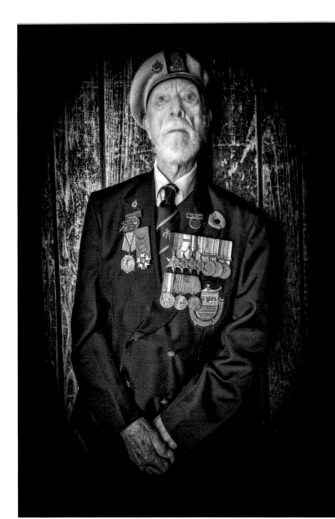

'Our warship was the first into French territorial waters at 2.30 am'

LEWIS TRINDER
SEAMAN – ROYAL NAVY
HMS MAGPIE – D–DAY – NORMANDY COAST

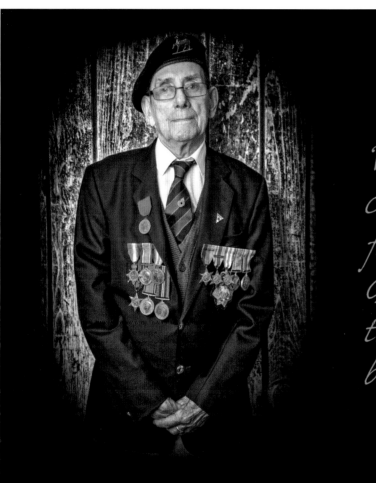

'We were like coconuts at the fairground ... the Germans were throwing all their balls at us'

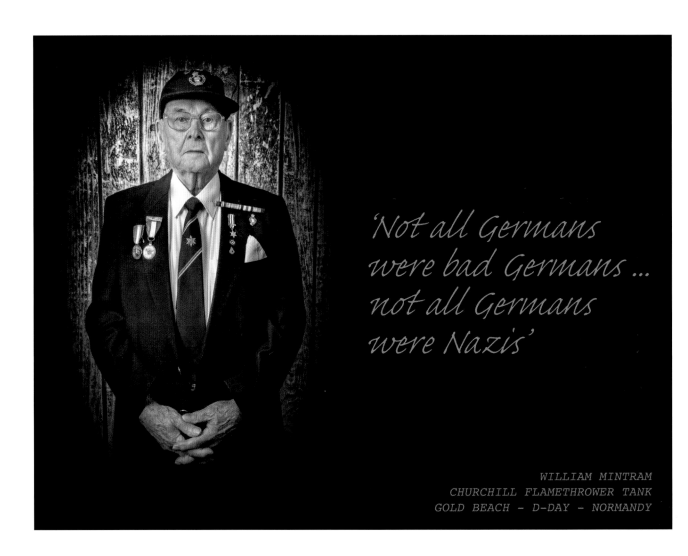

'Not all Germans were bad Germans ... not all Germans were Nazis'

WILLIAM MINTRAM
CHURCHILL FLAMETHROWER TANK
GOLD BEACH - D-DAY - NORMANDY

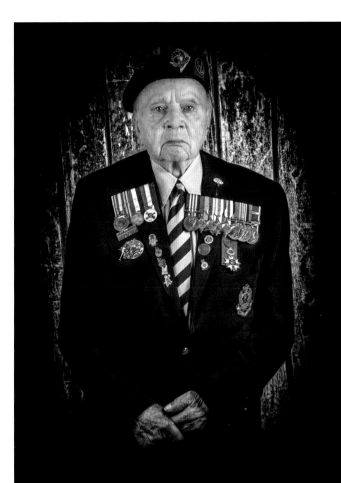

'I turned to our cook
and said, "make us
all a cup of tea ...
the war is over".'

JEFF HAWARD
MACHINE GUNNER – 51ST HIGHLAND DIVISION
BREMERHAVEN – NORTHERN COAST OF GERMANY

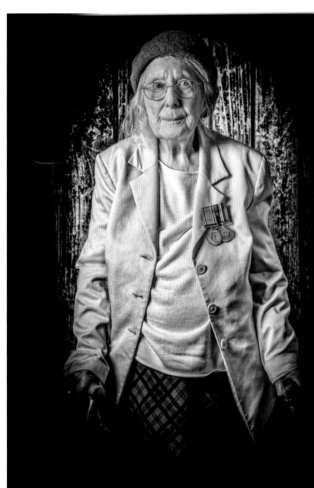

'We didn't go down into the air raid shelter ... we were much too brave'

RUTH JOYCE GILBERT
COMMUNICATIONS – WRENS
ARMED FORCES COMMUNICATION HUB – CHISWICK

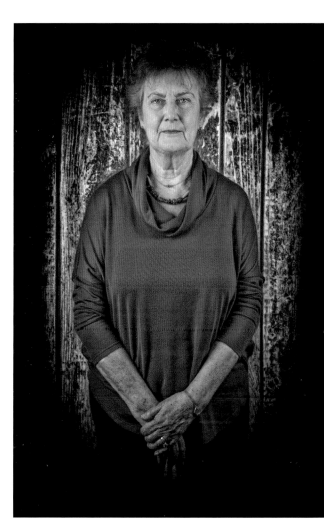

'My favourite toy was made by a German prisoner of war who lived on our farm'

ANITA HOLMES
EVACUEE
POULTRY FARM - FIVE OAK GREEN - KENT

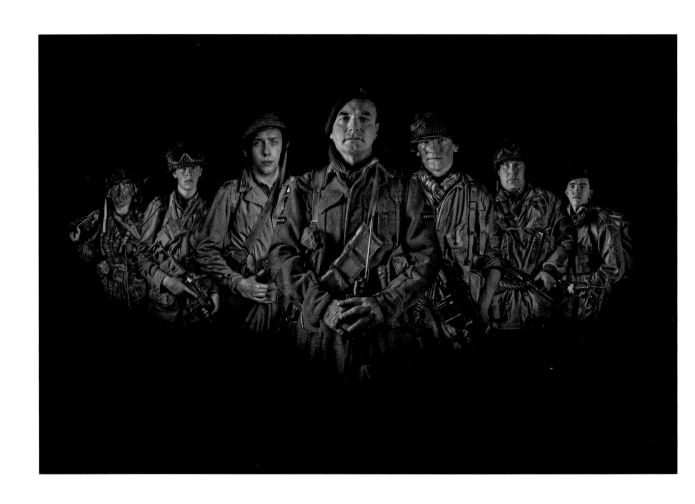

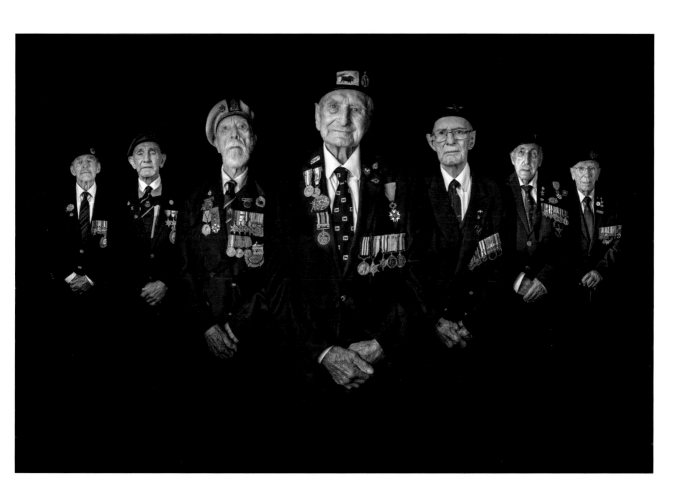

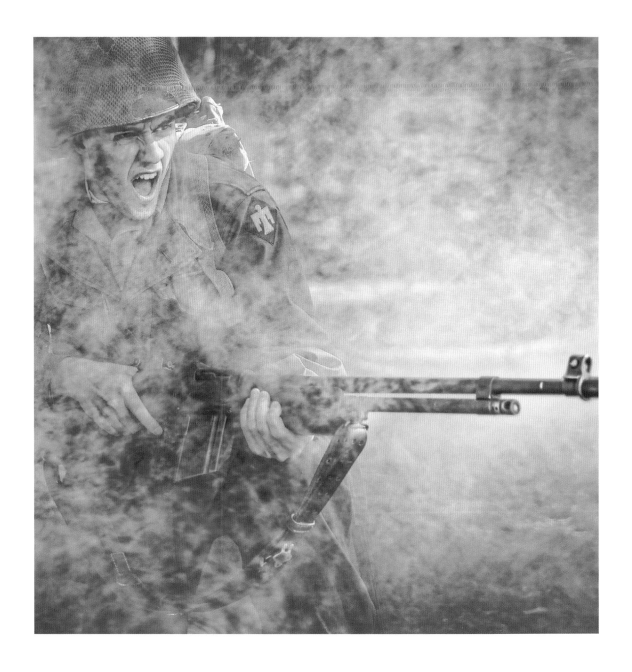

ACKNOWLEDGEMENTS

This is the part where I get to thank you for your interest and everyone else who has given up their precious time to be part of this project.

First and foremost, my family for putting up with my long weekends away, leaving my wife Kristen to take our son Cameron to football practice, and our daughter Kaitlyn to ballet lessons.

To a dear friend Beverley Cooper, the 53rd Welsh Division representative, without whom I would not have met the wonderful veterans in this book. Your dedication to all who fought is an inspiration – thank you.

The World War II veterans and their families: it was an absolute privilege to have met you all. Inviting me into your homes, and hearing your heart-warming and sometimes tearful stories, was a very humbling experience which I shall never forget and for which I will always be thankful. To the few who are no longer with us, your memories will never be forgotten.

To all the re-enactors and living history groups who have dedicated their time, knowledge and money into a passion that they pursue to commemorate those who fought in World War II, I thank you all: the Suffolk Regiment Living History Society, Just Ordinary Men, Ben Hilton and the 1st Infantry Division Living History Group, the US 2nd Infantry 39-45 Society, Screaming Eagles Living History Group, Home of the Brave Living History Group.

Special thanks to Pat Davies; I really enjoyed our chats over tea and cake.

Many thanks to Mary Stewart and The Spirit Of Normandy Trust, Victoria Phipps and D-Day Revisited, Nicola Caton and the Temple At War team, The Bourne Society of north-east Surrey, Nigel Worn of St Anne's Church, Kew and The Royal British Legion.

A big thank you goes to Lord Strathcarron and his team at Unicorn Publishing for giving me the chance and having faith in a project that means so much to me.

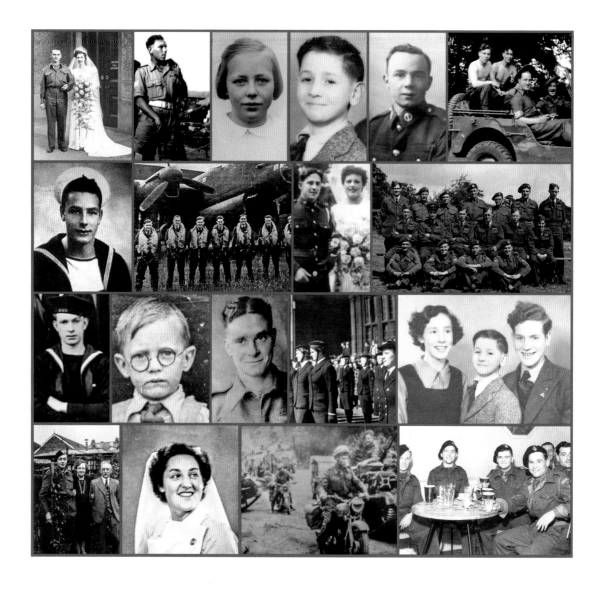